Leadership Lessons
From

Mom

Mark Villareal

Best Wishes,
Mark Villareal

Published by Best Seller Publishing®, Pasadena, CA
Best Seller Publishing® is a registered trademark
Printed in the United States of America.
ISBN-13: 978-1544105192
ISBN-10: 1544105193

This publication is designed to provide accurate and authoritative information with regard to the subject matter covered. It is sold with the understanding that the publisher is not engaged in rendering legal, accounting, or other professional advice. If legal advice or other expert assistance is required, the services of a competent professional should be sought. The opinions expressed by the authors in this book are not endorsed by Best Seller Publishing® and are the sole responsibility of the author rendering the opinion.

Most Best Seller Publishing® titles are available at special quantity discounts for bulk purchases for sales promotions, premiums, fundraising, and educational use. Special versions or book excerpts can also be created to fit specific needs.

For more information, please write:
Best Seller Publishing®
1346 Walnut Street, #205
Pasadena, CA 91106
or call 1(626) 765 9750
Toll Free: 1(844) 850-3500
Visit us online at: www.BestSellerPublishing.org

Dedication

This book is dedicated to my mother, Mary Alice Villareal. Her maiden name was Torres, and I include the Torres family with my dedication as a big influence in my life. God Bless.

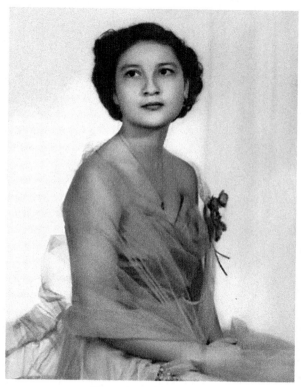

MARY ALICE VILLAREAL

Acknowledgements

Life is a challenge. Our parents are living it as they are teaching us, hoping and praying they can smooth the way to help us avoid the heartache and setbacks they may have encountered. However, heartaches and setbacks will come. Our parents know that, so they try to prepare us as best they can for when those come, as they know we must persevere.

As in my dedication, I dedicate this to my mother, but also to all mothers out there fighting the battle of life. Moms are special, and should receive the ultimate respect. My mother had the luxury of being a housewife and with that luxury she made a conscious choice to be content at being a housewife and raising us. In today's world it may not be as easy, and maybe it wasn't back then. I dedicate this to each mom who is fighting the battle and teaching their children the lessons of life. I dedicate this to the single mothers who are fighting it from all sides, but have the "I can't lose" attitude that drives their success in life and in raising their children. I dedicate this to the working mothers who are striving to bring to their children all that we want for them as parents. A chance. That is what we strive for. A chance to be happy, and a chance to be safe. A chance for success, and a chance to make a difference.

Moms, this book is for you. It is important that each of you understand that you are admired, respected, loved, and do make a difference in your child's life. Moms, you make the biggest difference in the world, period. You shape the minds and the spirits of future generations to come. Once again, moms, this one is for you.

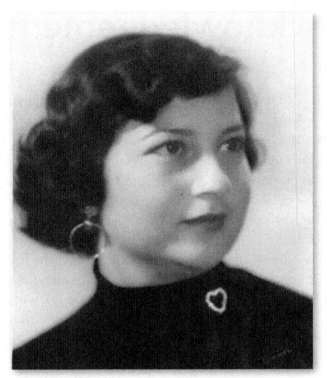

MARY ALICE "TORRES" VILLAREAL

Forward

I was blessed to have two loving parents who taught me so much. My father was a stern man and up until his passing, he was the strongest man I knew. My mother was a loving housewife dedicated to each of her children with unconditional love. Both parents taught me so much about life and walked me through my development. However, having been the youngest of my mother's 5 children, I had a special relationship with my mother. I am not saying she loved me any differently. Like with any loving mother, each of my brothers and sisters will also state they had an individual relationship with Mom. But in my mother's special way, each was different and unique.

I believe by being the youngest, my mother had already experienced many trials and circumstances with each of my siblings that added to her wisdom. In addition, my mother's faith in the Lord allowed her to sometimes let us make our mistakes trusting in the Lord that the lesson learned was of more value. My mother also never hesitated when giving out punishment, validated by our actions, and in her wisdom and in her love she allowed the punishment to be carried out in its entirety knowing the shaping of our character was more important than our sorrow in the moment. Like any parent she hated to see us suffer. I know at times that we were harmed, she wished she could take the pain away or take it upon herself. Nothing breaks a parent's heart more than to see their child suffer.

As the years went by from early childhood through to my pre-teen years, so much changed in my life. Having a family of 5 children in the household, and being the youngest, I witnessed many heartbreaks and lessons from my older siblings. In some ways I also saw how they affected my mom. She was a strong lady, but I could sense when she was saddened or disappointed. Like the way she felt pain when I felt pain,

this was the reverse feeling as I surely felt hers. In many ways this also shaped some of my future decisions, but I certainly made my share of bad choices as well as paid the price for them. However, through each of them, Mom's love was unconditional, as always.

In my teen years my mother only wanted the best for me, as most mothers do. It is when I look back at those years and certain instances that I see my mother's warning and the insight she had at the time. How can one housewife perceive so accurately and know so much? Mothers are incredible. She could perceive friends who were bad influences from meeting them only once. She was obviously very cautious on the girls I brought home. But sometimes, we as children, do not heed the warnings and mothers know this. Because their perception is so keen they are ready with their wisdom when we fall and need guidance. Certainly, both parents play an influential part. But Dad worked and Mom was always home. Dad added wisdom as well, but Mom was the follow through. Mom was the perfect balance to Dad, and allowed him to be the "man" of the house. This just meant that she observed the pecking order and taught us through her example about respect, chain of command, and how the organization of the household operated. This does not take away from different styles of households or the single mothers of today, as I respect them immensely. It was just how it was in our house.

When my mother started having strokes, it took a toll on me. I saw how her years of chain smoking took an effect on her health. Funny, but from witnessing her smoking over the years I actually learned not to be a smoker, so even in her weakness she taught me this. But the lessons of her ailing health and the years that followed showed me how Mom even changed my dad. Her influence, and yes with God in control, changed my father to outwardly showing his love, devotion and care. In her passing she showed me God's timing is perfect. My father passed two years later yearning for my mother. But those two years were the most amazing transformation of a man seeking our Lord that anyone had witnessed. At his funeral strangers spoke about how my dad's devotion

changed and influenced them. How amazing it was that Mom even taught me lessons through her death and passing.

I think of Mom and Dad constantly. I pray I am putting a smile on their faces. I do not believe there is a day that goes by that I do not remember the lessons I learned. My mother was the best leadership coach who chose to be a housewife. It was a happy choice for her and a blessing for us. Today, I see that in her wisdom, Mom knew that the lessons then would have meaning to me throughout my life. It is amazing how Mom prepared me to lead, and how much she knew about the parallels of business.

In "Leadership Lessons From Mom", I write about the lessons learned and how they relate today in everyday life and leadership. I will be the first to state that my mother did not create all the fancy statements or even the lessons, as many of us have heard them constantly over our life. But what I do state is that my mom had a way of using them to relate to life at the moment with the future in sight. Mom knew she was shaping me for a lifetime, as most mothers do.

Table of Contents

The Early Years – Laying a Strong, Lasting Foundation

A) RIGHT VERSUS WRONG.
(THE LITTLE VOICE IN MY HEAD)

Moms will always teach about right or wrong. I believe this is the very foundational, yet continuous lesson mothers have to teach. I am amazed that the lessons of right versus wrong are at every stage of our life from very adolescence, pre-teens, teens, early adulthood and I am sure up until death. I have no doubt that we all have faulted in the area of right versus wrong.

There I was, in elementary school, admiring a toy another classmate brought for show and tell. Soon it became time to go home, so we all started putting things away and packing up to leave. I observed the classmate who brought the toy, packing up and the toy was on his chair as he was packing up his desktop items to go home. It seemed he was unaware that it was on his chair and so I was watching to see if he was going to leave it out and forget it. As he finished packing my assumption was correct. The classmate packed up and walked away with the toy still

in his chair. I was sure he probably believed that he had packed away the toy and would not know where he left it when he discovered it was missing. I went over, grabbled the toy, and placed it in my bag quickly, yet calmly, so I would arouse no suspicions. After all, "finders' keepers, losers' weepers", correct? Wrong! I quickly found out shortly after arriving home and when my mom noticed the toy that I was playing with.

"Where did you get that toy," she asked.

I was not quick to answer. I hold to the belief that when we are young, we believe in the tactic that pretending we did not hear will work. In fact, I think many of us men still believe that today. But my mother was not having any of that.

"Marcos Antonio," she stated.

Now she had my attention. My mother used my first and middle name in Spanish to always get my attention. The more commanding she stated my name, the more I might be in trouble. This is probably leadership lesson number one. A leader defines and communicates to those that they are leading, how they communicate and what the different stages of that communication mean. My first and middle name in Spanish meant I better listen and pay attention, and if she had to say my first and middle name in Spanish again, I was in trouble. So I knew I had to pay attention, as I turned toward my mother, but still said nothing.

"Marcos, where did you get that toy from?"

"It's mine, Mom," I replied

"Marcos, that is not what I asked. Pay attention. Answer me, where did you get that toy from?" She looked at me sternly. Leadership lesson number 2, be direct, and be specific.

"Mom, I got it from school. Some other boy brought it in and left it behind."

My mother had a way of giving a look, an expression, that when given you know she is seeing right through you. Little did I know that this was part of another lesson that I learned later in life. She allowed me to speak, and it was her way of giving me enough rope to hang myself,

or save myself. But at that moment she did not immediately correct me. She wanted me to either talk my way deeper into trouble or out of trouble. My mother knew that is what I would do. In her desire to build good character in me, she allowed me to either tell a bigger lie, leave out facts, or dance around the truth. Through this, she knew that I would feel guilty and it would show in how I was acting and talking. It was that little voice in my head telling me the difference between right and wrong. Finally, my mother stopped me from speaking, as my answers became conflicting and confusing.

"Marcos Antonio, I want you to tell me the truth."

As a child I still tried to rationalize. "Mom, the boy lost it, and I found it. Finders keepers, right Mom?"

"Marcos, did the boy say you could have it?"

"No."

"Did the boy say he did not want it?"

"No."

"Then what does that little voice in your head say?"

Mom knew how to question. As a mom, and as a leadership coach of a 5 year old, she knew that by walking me through the process that this was a coaching opportunity for her and a learning experience for me.

I had to answer, and my mom led me to the point of no return. I could say "know" return, as she knew I should know better. "Mom, the boy did not say I could have it and he did not say that he did not want it. But he did leave it behind!"

"Marcos Antonio!"

That was it. Leadership lesson number three. Leaders must know when to take control. This was my mother's way of taking control.

"Yes," I stood there with tears in my eyes. I knew I was in trouble, and it was the voice in my head telling me that I was.

To sum up the story, my mother took me to school and had me hand it to my classmate. As a mother, she wanted me to know the difference between right and wrong. She also wanted me to develop good character and feed that voice in my head to always be there. Her

method was allowing me to realize and understand what was wrong. Knowing was only phase one. Phase two was walking me through the stages of correcting the wrong, which was confronting the other classmate and letting them know that I had taken their toy. I needed to feel the embarrassment. But her biggest lesson was to teach me to hear and listen to that voice in my head. Over the years, she would explain and ask me about what the voice in my head was telling me. She would explain, "Mijo, your conscious knows when you are doing wrong and it will tell you. At times when you are unsure, listen to that voice in your head and question yourself. If you are still unsure then ask me or your father. When you do this, when learning how to make a decision, then we will appreciate you asking, and others will too."

Growing up, there are so many examples of my mother coaching me in right versus wrong. Each time she asked about the voice in my head. When I got caught cheating on a test, or when I just simply did something wrong by being mischievous. Soon I learned the little voice in my head would train my instincts. We all have instincts, but if they are not trained and tamed by that voice in our head the instincts can be deceptive. Mom's take the responsibility of training and taming that voice in our head, because our character is so important and the older we become the more difficult it can be to train. Mom's take that responsibility by realizing that this is an important foundational piece of our development for shaping who we are and who we will become.

Because my mother helped develop my habit of hearing and listening to that voice in my head, my instincts of right versus wrong developed deeper. It allows me to see where and when I may be tempted to cross the line of right versus wrong, or take a shortcut on a principle. Which is another part of another lesson.

In business, we as leaders and managers of others must not only listen and hear what that voice in our head is telling us, and how it makes us feel, but also how it defines part of our instincts. As a leader I teach those leaders in development the same principle of being cognizant of

that voice in their head. The lesson utilized to bring it out is simple questioning of the individual.

1. What is the circumstance, please define?
2. What are the objectives and goals?
3. What are the alternatives and choices?
4. What does success look like?
5. What choices seem right and valid, with ethics being upheld?
6. What choices sacrifice integrity, ethics, honesty or a principle?
7. Even if difficult, what is the right decision?

Working through the process and allowing that individual to answer honestly, openly, and without feeling ashamed, you can help that person develop immensely. As a coach and a leader it is imperative that you create a relationship that the individual knows that you will be honest, factual, and challenge areas that cross right versus wrong. Developing the proper character of a leader is the most important aspect as a true leader must demonstrate integrity and honesty. By mentoring and working the future leaders and managers through the seven question process, you are establishing in them the same instincts they learned in childhood, hopefully, that I did from my mother. Those that follow and watch the actions of a leader will admire that leader even in times of difficulty if that leader still makes a decision of what is right, and suffers the consequences, than what is wrong, to avoid any consequences.

B) BE A PART OF SOMETHING

My mother walked me to school when I was in kindergarten. She had a friend that lived across the street who had a son 21 days older than me, my friend James. Ironically we even had the same last name except ours had one less "r" in the spelling. James would be one of my best friends for life. Many believed, and we led them to believe, that we were cousins although there was no relations that we knew of. It was nice having a

friend of the same age living on the same street and attending the same classes. However, having James always there became easy as he was who I would hang around with, play sports and games with, and join groups with.

As what happens in schools, even those you are close to just somehow get separated in other classes and other teams, groups, and projects. But that wasn't fair, as I wanted to participate with James. I was comfortable with James and hanging out with James became a comfortable environment. Soon my mother would receive reports of instances where I would lack interest or lack participation in projects and in group activities. My mother took interest to see if she could determine what was going on with my interaction and lack of interaction as was being reported. In some ways I was becoming an introvert when I was not around comfortable surroundings. I would revert to being quiet and subdued, and less interactive with others. I would imagine some mothers would not recognize this as a concern as my mother did. She not only saw it as a concern, but she wanted to take action on changing this in my behavior, as she knew that this would be for my benefit. My mother recognized that the best development for me as a child, that would have an effect of who I would become as an adult, would be to teach me to interact and to engage with others.

Soon I saw my mother participating in many of the school activities so that she could encourage me to participate and interact as well. She signed me up for outside activities and encouraged me to play sports and other outdoor activities for my development. I was enrolled in gymnastics to allow me to compete with others and to interact and engage in a team environment. Finally, I remember my mother sitting me down and explaining. "Mijo, I want you to always seek to be a part of something. I want you to contribute if it is a team environment and I want you to compete to do well and improve if it is an individual situation. Marcos, it is important in life that you learn while you are young, that the more you push yourself to be a part of something then the more something will seek to be a part of you." What wise advice.

I now see how that correlates to business and adulthood, as well as who I am now. There are many tests and analysis' out there that businesses utilize that help to define who you are, what are your strengths and weaknesses, and how you are perceived. Funny, but one such test done on me states that I am more comfortable participating with a select group of people and can become introverted around strangers. However, when others who worked in the same environment as myself read that statement, they saw it as an inaccuracy since they see me as being so extroverted. They see me as very sociable and at times the one who seeks attention, and especially one who is very competitive. The truth lies in the fact that the analysis picks up my natural tendencies. It is because I became aware of these tendencies, because of my mother's efforts, that I then understood how to attack and overcome them. This was my mother's leadership skills at their best.

As a leader, I look to recognize traits in our individuals and assist them to confront and work with them on their skills - to not only attack the issue but to confront it openly. A natural tendency will always be there, but the skill learned to understand that tendency and to learn the ability to overcome the tendency can make a huge impact. Today when I speak and give presentations, others may not see that natural introvert in me. It was the recognition from my mother's leadership skills and her desire and focus to coach me that has taught me to address it and confront it head on. Leaders can have such an impact. Leaders see this as a responsibility.

Over the years I have been amazed and blessed by being associated with and mentoring individuals that have the hidden qualities within themselves that they may have been resistant to, or did not recognize it themselves. Human nature teaches us to stay in our comfort zone. We feel safe in our comfort levels where not much could go wrong. However, much like my mother saw in me, we as leaders must recognize hidden or needed skills in others and that we have a duty to help those individuals expand and grow. This, at times, requires us to take that person out of their comfort zone. I was a natural introvert and I still am today, but

my mother knew that I could build the skills and the confidence to push myself in the uncomfortable environment that required extroverted skills. I would not have had the success I have enjoyed to this moment without being pushed outside my comfort zone.

C) REWARDS OR CONSEQUENCES

There I was, in trouble for causing mischief at school. Yes, I was kind of a class clown, and class clowns live for the attention they receive. But as my bad conduct report made it home for my parents to be informed I knew I would have consequences.

Rewards or consequences? This was a phrase my mom would simply state. Unfortunately, she would sometimes repeat the statement as well. It was important for my mother to teach me that life is all about rewards or consequences. My parents showed me many rewards for good behavior and good deeds. Good grades in school, good deeds and conduct at home, or just doing my chores without having to be reminded brought rewards. It was great to be on the rewards side.

Rewards or consequences? Yes, that statement usually meant I had to be reminded about consequences, which usually meant I did something wrong. My mom, who was the best leadership coach who chose to be a housewife, wanted me to experience both sides as it was important to her for me to understand this form of behavior modification.

My mom explained to me. "Marcos Antonio, rewards are there for you in life and you will have to learn that it is best to place yourself on the rewards side. When you have a family and are working hard, your employers will use the same technique. You want to be known as someone who deserves, earns, and responds to rewards. There are consequences for everything we do. But in this context the consequences I am speaking about are what occurs, and what you will receive, because you did something wrong or incorrect. Not only will you suffer the consequences of your actions as they usually bring unwanted results, but also the consequences on how others perceive you."

Rewards or consequences? Mom, I certainly have had both in my life. And as you taught me, when its consequences I must face them head on and need to take responsibility allowing the consequences to teach me to be a better man for it. Hopefully I have done this. The rewards and consequences I have encountered have made me who I am today. It makes each of us who we are. Mom, you taught me to allow both to develop my character. As a mother you may have not wanted to see me face consequences, but you knew I needed to. That is a sign of a mothers love.

As a leader in business, I teach all those in which I am responsible for that we have rewards or consequences. We reward good behavior in work execution. We reward those that are coachable and those that achieve good results the right way. We want rewards to be visible and desired. We like to point to success. The One Minute Manager teaches us to catch someone doing something right. This is an exact form of working from the rewards side. But as leaders we must also teach and show that there are consequences for not executing, not adhering to policies or processes, or not being coachable. We confront it, explain it factually, and reset expectations. As a leader I may not want my employees to have to face consequences, but much like my mother I know they need to.

I remember once feeling jealous in regards to my brother, as it appeared he was truly constantly receiving rewards and it seemed to me, that I was held to higher standards. As children, we sometimes look and have a perception of what is fair and what is not fair. The caution as a child may be that we see it from our point of view and from our eyes. I remember speaking up and asking my mother about how my brother was being treated more with rewards and that this was unfair. Of course my mother had a response ready. My mother seldom hesitated and it always amazed me how quickly she responded. She turned to me, and simply broke down the facts of things I had done that at the moment was keeping me on the consequences side. She made it clear I should be less concerned of my brother's actions and his rewards if I was

unable to recognize my current status and the cause that affected my state. This was part of her brilliant leadership skills as she addressed my discontent, and pointed out the facts and clearly demonstrated that I was responsible for my actions and my discipline. She would at times even ask me, "Did I not make it clear that you will be rewarded or face consequences based upon your actions? In addition, did we not discuss that as soon as you correct yourself and show improvement, and show that you have listened and are making an effort that I would recognize that?" My answers were always yes.

The biggest lesson in the rewards or consequence conversation with my mother is it always reverted to the fact that we were educated as her children and that she would manage this way. She would emphasize that it was because she wanted us to listen, learn, and to grow up responsibly. She would always state that rewards or consequences would create our character and help us live our values and stand on our principles. Great leaders are great educators. Nothing is a surprise. Great leaders, like Mom, coach and gain commitment, knowing that at times she would have to remind us of our commitment.

One tactic I teach in leadership and that I use, is that I manage with rewards or consequences. I then explain and define what that is and I point to examples. Much like Mom, I explain that I am looking for good effort, and for those who listen, which in business that means those that are coachable. Much like my mother, I also clearly define that I would much rather manage with rewards, but that I understand that consequences are essential in their development. In addition, at times I might lighten the consequence based on the seriousness of the action. At times I may need to allow the consequence to take its full effect so the result of the consequence would hopefully take its full effect and help us recognize to avoid making the same choice again, as well as make correction from that action. Sometimes there is danger in not allowing a consequence to take its full effect, as then that may become expected. Mothers do this out of love. Leaders for much the same reason, although our ego may not allow us to admit it.

Finally, I always explain to others, as my mother did with me, to be concerned with my own actions and my own rewards or consequences. However, at times, if I truly believed it was unfair my mother would use facts and show the difference. A leader in a business can do the same. But also, a great leader like a mother, will also define their individual expectations of you. My mother had high expectations for all of us, but they were also individual expectations based upon who we were and at what level of development we were at. Legend has it that the great Dallas Cowboys running back, Emmitt Smith, once asked his coach Jimmy Johnson why he was being so tough on him? After all, Emmitt followed the rules, was never late and did all what was asked of him. Jimmy Johnson responded, "Because I have higher expectations of you and if I show that I hold you to a high standard then others have nothing to complain about." Emmitt understood and accepted the higher expectations. When high level performers do this, they become leaders themselves and great examples of the type of individuals you need and want in your team environment. Great players, like employees, can affect the culture in a positive way to push and hold each other accountable. I teach, as others have taught as well, that A Level Players want only A Level Players on their team. B Level Players will gravitate towards the A Level Players unless you also have C Level Players on the team. They can make the B Level Players gravitate towards them instead. Leaders must define and understand each level and each individual. C Level Players are the ones who do not take, listen to, or react to the coaching.

D) DREAM BIG!

One of my favorite memories, and also one of my greatest joys, is to see how we dream big when we are young. We have a couple of boys that we consider our adopted grandchildren that I love being a part of helping them dream big and fantasize what they can become. Jack and Warren are beautiful brothers who have loving young parents that take great responsibility in raising them. I appreciate the love and leadership they

take in raising them, but I also truly appreciate that they allow us to be a part of it. Jack is the oldest and he was born with digestive difficulties, but has grown healthy. Warren, his younger brother, appeared very healthy at and since birth. Just like any younger brother he wants to be like his older brother and wants to be included in his older brother's activities.

When Jack was young we would buy him harmonicas, flute-like instruments, kazoos and even a miniature guitar. A few things amazed me. One, Jack kept such good care of them, and two he would put them away each day and ask before bringing them out. Respect starts from how he was raised and he knew it no differently. But the other amazing thing is when his younger brother was born and as he grew, Jack loved sharing his toys and was anxious to hand them down and offer his brother encouragement. I believe this is also why his brother Warren wants to be like Jack. Their parents have truly taught them well.

The one thing I love about being a part of their lives is to work on things that allow them to dream big. When I was at the Smithsonian, there was an astronaut uniform for children for sale. I could not resist and purchased one for Jack, as Warren was still a baby at the time. The joy when I received pictures of Jack wearing the uniform and having a costume party so he can proudly display this uniform was nice. We also subscribed the family to Smithsonian Magazine, knowing that his parents participate and read the articles to the boys. This is a big part of leadership, when leaders participate in their employees dreaming big. Leaders can play a big role in the encouragement of big dreams and in attacking them. Next, Jack wanted to be a Park Ranger and I am like a kid myself when I find things that will help nurture that dream. I found a National Jr. Park Ranger vest, a backpack and other items and sent them for Jack's birthday. But the best part is, I included items for his brother too. I created a letter on fake letterhead from one of the parks and sent it to Jack as a recruitment letter into the Jr. Park Rangers. The letter explained to Jack that we admired his interest and his work so much that we wanted him to groom his brother. The letter was signed by the legendary Brock Cliffhanger! I needed no credit, because I had all

the joy. Jack's mother wanted to tell him who it was from and I let her know it was more important to me for him to believe in the dream than to know it was from me. There is no better joy I receive than to get pictures of them playing in their outfits. On the 100 year anniversary of the National Parks their mother baked a birthday cake and they celebrated.

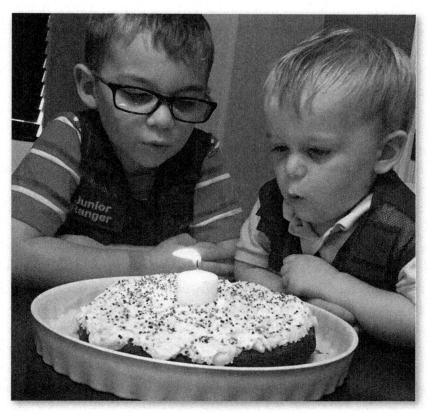

JACK & WARREN

Why am I writing about these boys and not my mother? Simple. I learned this from my mother, and yes both parents. By learning and developing to dream big and to become a leader, I also know that great leaders pay it forward and I desire to be a great leader. When I was young, I had sports idols. Len Dawson was the quarterback of the Kansas City Chiefs and I wanted to be like Len Dawson. For Christmas I received

a full tackle football outfit in red colors so I could look like the Chiefs. What was also important is my mother took the time to understand who Len Dawson was. It was important to her that if I was going to dream big, then it was important who my role models were. Len Dawson was and still is a man admired for his character, charisma, and leadership. The city of Kansas City still adores him to this day and he has always given back. This is another great lesson on leadership, it is important to know and understand who the examples are to ensure those we are leading are following the right examples. My mom wanted me to dream big and believe I could become Len Dawson.

I grew up a Dodger fan and have remained one until this day. However, for some reason I did grow up loving and admiring Carl Yastrzemski of the Boston Red Sox. I remember the love and admiration the team, fans and the city of Boston had and still have for the man. I believe in my younger years people admired individuals for the right reasons. Once again, much like Len Dawson, Carl Yastrzemski is a man of good character, charisma, and leadership. He gave back to the city. As an athlete he believed in and worked for the team and also pushed the team. I sometimes wonder how a Dodger fan became a huge Carl Yastrzemski fan. I am suspicious if my mother, the great leader that she was, did not influence who my role models were. Great leaders are able to influence and understand that their influence in us is a responsibility. If my mother did sneak in Carl Yastrzemski, I certainly love her for it.

Here is why I believe my mother lovingly pointed me towards the right role models. Because one lesson she taught me when I was young and reminded me over the years was an exercise to define the qualities of my heroes. She would want me to list out those qualities. This, for certain, showed it was important to her who my role models were. She would then ask me why those qualities were important and this showed that the proper understanding of the right qualities was important to her in my development. Once she was satisfied, she then would challenge me to demonstrate those qualities and state that if I am able to demonstrate and emulate those qualities in my actions, then I actually will become

like my hero. This was a great teaching exercise. I have utilized this exact exercise in business. I have held sales meetings and walked each employee or member of the team through each step of the exercise. I would then take it a step farther and have each person speak out and let others know who their heroes are. Next, I would have them display the hero document with the qualities listed on the page at their workplace or cubicle and challenge them to become their hero. We would walk around and have discussions about their hero, their fondest memories of that hero and you would see the joy in their eyes. My mother knew, as I have seen in business, that role models are important to people. They shine and become more expressive as they discuss and display their role models and heroes.

Then why do we struggle to dream big as we grow older? When we are young the whole world is ahead of us and anything is possible. My mother worked hard for me to always believe that anything was possible in my life. That is what leaders do. When we grow older we experience roadblocks and disappointments that then teaches us fear and worry. My mother did several things. She talked about dreaming big and continued to show her faith in me and my abilities through her whole life. In addition, my mother also recognized the roadblocks, disappointments, and sensed the fear and worry. She could not always take away the disappointments or remove the roadblocks, but as a leader she would continue to encourage and coach me. She would even be open about discussing my inner fear and worry to help me through it, and many times to help me see that there was nothing to fear or worry about. Most of the time we tend to over exaggerate the situation which expands the fear and the worry. Mom helped me to recognize that. Finally, she would coach me to learn from the experience and even help me to understand that sometimes I needed those experiences. I needed to allow them to be a learning curve as they developed my character. We as leaders must do the same in business and with those we lead. Because we cannot prevent all disappointments, and some might add value, we can encourage, coach, teach and help those we lead to continue to

dream big. We need to also step back and evaluate our dreams. Are we dreaming big today?

E) VALUES AND PRINCIPLES

I can still hear my mother's voice and the tone of her voice speaking about values and principles. I believe all parents attempt to teach values and principles, but they may not be as direct in the teaching. Should they be? In today's society I hear so much from parents on important subjects that involve values and principles that they state, "We are going to let our kids decide as we choose not to push this on them." Is this the correct way? Is the freedom to let our children choose a smart decision?

I have a great friend who has a young boy turning 13 years old, an important age. I am one who has a strong Christian faith and that is part of my value system. It may not be part of other individual's value system, yet they have strong values of respect, honesty, and ethics, as we each can derive them from different beliefs and lessons. My friend's boy is very respectful and you see a lot of his mother in him. She definitely is a strong leader for her son. In conversations that we discussed over different times she mentioned things that were important to her, but stated she would let her boy make his own choices. I questioned her if she felt strongly in her beliefs and if they were centered on the right values and principles, and she emphatically said yes and that they were. I then asked, "Why would you not teach them to your son if they are so important to you and instead you allow him to be taught by the world?" She stared at me. I then made a simple statement that I learned from my mother, that if you do not teach your children on the way to go then the world will teach them, and at that time it may be too late. My friend had a blank stare of reality. She explained that her sister's 18-year daughter just ran off, and although she was 18 years of age, and of legal age, they were concerned of her making bad choices. My friend then decided to take a more active role on her son's decisions, and he has since accepted the Lord and has been baptized with great joy in his heart. Certainly

he will still have his challenges, as we all do. But her sister has now commented with the statement, "I wish I would have not left it up to my daughter to decide what values were important to her and that I taught her like you taught your son." I pray her daughter comes around.

Values and principles? What are they? We hear these words when we talk about leadership. We hear them when we conduct strategic planning. We hear them when building our mission and vision for our organizations. Bold companies actually list them front and center for their clients to see.

Values and principles? Wikipedia states that "values generate behaviors." The definition speaks of morals and ethics, integrity, honesty and respect. In businesses we may add on teamwork as a value. A leader may add humility as a value trait.

Wikipedia states that a principle is a "rule or law that has to be, or usually is to be followed." It further states that values are what build the principles that we live by, manage by, and lead by. In our businesses and in leadership values and principles are the very foundations that everything else is built upon. Your mission, vision, initiatives, strategies, and business plans need to all point back to them.

My mother knew that instilling the right values and principles and my understanding the importance of them would define the very core of who I was as a person, and the very core of every decision I make. When I was very young, I spoke about how she defined that I would be raised with rewards or consequences. She further defined that those rewards or consequences truly point back to my value system, which are the values that I deem, and she deemed, important. Like a great leader, teaching and coaching me, she demonstrated her value system and set of values. This is part of leadership and why my mother was so good. Mothers do it instinctively. My mother laid out her values and explained each one. Love, respect, honesty, integrity, and ethics. She defined to me in simple terms so I would understand as much as I needed to. She would ask what my values were and they were much the same when I was young, as they made sense. People want to be led by nature and as children we

definitely look for leadership from our parents. My mother knew she had the best position to have an influence on my values system and that I understood what they were and why they were important to her, and why they should be important to me. Leaders do not shy away when talking about values; they go directly into the very subject.

As I grew, and yes, as I found myself in trouble, my mother would ask about my decision on what landed me in trouble and asked me what value it violated. This was such a strong lesson from my mother, teaching me why values were so important. She would teach me that all decisions should be tied back to a value and even in times of not living a value it was important to her to show me where I went astray. This is when my mother started teaching me about principles. You see, to me values and principles seemed to be the same thing, but now my mother is teaching me the difference. This is true leadership. My mother finally looked at me and stated, "Mijo, values are what you live by and principles are what you stand on." Wow, sounds great, but what did that mean? She then walked me through each value and demonstrated how honesty is something you live by, just like respect and love. She then explained that when those values become principles, they then become automatic. Automatic meant without hesitation, or having to think about it. This is what any parent would want for their child as well as any leader in business. Imagine the comfort of when faced with a decision knowing that if it crossed ethics, the decision would be automatic. This is also a sign of a strong company.

Over the years and as I grew, my mother would also teach me that I needed to assess my values system and see if new values needed to be added. In my teen years, she would express humility and define it as a strength and not a weakness. As a teenager it may have been difficult to understand, because we learn about pride and there is confusion on what a "healthy pride" is and what an "unhealthy pride" is. As she saw me going into my adult years she expressed humility even stronger as it was important to her on how I carried myself. Leaders understand this and need those they mentor and lead to understand the decision

making process of values and principles and how every business decision should point back to those values and the principles, which should be automatic.

Why is this important? It is important for many reasons. One, it establishes the culture of your organization and this culture is the very thing that you should desire throughout. Two, if you strongly believe that the values and principles that are built are the ones for your organization to live by, then building each plan around them is a strong foundation for success and for others to adopt and carry out. Finally, they need to be daily reminders to our leaders as well as employees and to be exhibited to our clients.

I once had a customer ask at a client meeting to our sales representative, "What is your Mission Statement?" This was the very first question she asked and it instantly told me about their organization. The question told me that mission, vision and values were important to them. Not only should our answer be automatic when asked about our Mission Statement, we should naturally be able to explain the Mission to the customer and why it would be important to them as, after all, our mission should describe and point back to the very values and principles we defined.

Values and principles? Why are they important? They are important because values are what we live by and principles are what we stand on. If we truly live our values then our principles should be automatic, without hesitation. One morning I arrived in the office and there was $100 bill on the floor. However, my boss was in his office and he was the only one that had walked that path. In my mind I thought he might be testing me. But I will honestly state that I did not hesitate. I picked up the $100 bill and asked if he had dropped it, which he had. I do not think he would have known where he would have lost that $100 bill.

College Market Institute teaches in their Leadership Academy a session called, "The Moment of Truth." The lessons bring the leaders in the workshop through scenarios and tests them in their moment of truth to teach them what true leadership is. True leadership is living

the values and driving the principles those values have become to be automatic. Keith Martino of College Market Institute, one of my many mentors, has taught me that there is no weight of measure on not living a value. In other words, to break a value a little bit is just as bad as breaking it a lot. Keith has a way of explaining it so eloquently.

Thomas Henderson gives the ultimate test or measure when he states, "the true test of character is if you do the right thing when nobody is looking." Henderson explains that it is easy to do the right thing when others are watching, but true character, like principles, are automatic.

F) DOES EVERYONE REALLY GET A TROPHY?

Growing up, it was common that we played the three major sports of the time; baseball, football and basketball. Our park league would end one sport and go into the next sport. The leagues were competitive with many parents being coaches and assistant coaches, while others came to cheer their kid's on. It was fun, it was competitive and yes, we wanted to win. It was also very disappointing at times. When we would lose, we would be encouraged to do better. Our coaches would go over our mistakes and coach us on improvement. Then we would practice, practice, and practice some more.

What I remember most is the desire to play more, and wanting to win. When we lost it was discouraging. When other players on our team received more playing time, I would take my own initiative and practice at home with my brother to get better and earn more playing time. It was about performance and desire. Our coaches certainly had patience, and they were good coaches. In the end, the league would have the championship playoffs and the championship team would earn the Championship Trophy.

Our father, at times, participated in coaching us. Both parents attended games, encouraged us and even yelled out corrections. It was their participation, counseling, and yes, even consoling in defeat that helped me understand the rules of life. This, to me, was a valuable lesson and a great step not only towards understanding life, but also being

prepared for life. Winning was great while losing was not fun and even left a bad taste and feeling in your gut. We all wanted to do well. I believe we all wanted to play well and earn some recognition, and improve. We all learned that there were rewards as well as awards for team winning and for individual skills and achievement. This was the definition of how life is and will be.

Today, it seems we are rewarded just for participating. Certainly being encouraged to participate is a good thing, but it seems we strive even further in an attempt to make everyone not feel defeated by giving out trophy's to participate. Does everyone really get a trophy? I ask because I believe our upbringing prepares us for life and for business. Yes, life may have been disappointing, but when we didn't win a trophy we certainly set our sights for it the next time. When we needed to get better in our skills to earn more playing time, those that showed they were coachable, and even took initiative to develop more on their own, earned that extra playing time. Our disappointments taught us to overcome and try harder. Our parents and coaches taught us to self-evaluate and learn how to understand our weaknesses and make them better. Our experiences have taught us to take accountability and not blame others.

I remember that I was an okay athlete, not a superstar in any one sport, but I had the ability to be decent in several. My mother would encourage me to practice and took an interest enough to understand where and what areas I needed to improve in. When she would attend a game, she would encourage me and show by her attendance that she supported me. This is a sign of a mother's leadership, but correlates today on effective coaches in businesses leading teams and mentoring individuals. When my mother was unable to attend she would ask when I arrived home how I did. She would ask about specific things and areas that she knew that I was working on to improve. She would ask for my assessment of how I did in those areas and ask for any feedback my coaches gave me. My mother would encourage my older siblings to assist me with practicing, knowing I needed others' involvement. Great

coaches understand this and know that by getting others involved it will create a learning and participating environment.

I remember one time being hit in the eye with a baseball. My mother had the first natural concern of a mother to ensure that I was okay. Then she wanted to ensure that I still wanted to participate. If she believed for a moment that it might be dangerous or harmful, she would have said something. But she also wanted me to learn to fight back, stay competitive, and get back in the game. At times of defeat, or at times of disappointment caused by being cut from a team, not earning playing time, or maybe not earning the position I wanted, my mother was quick to coach me. She showed me that coaching meant many things. First, it might be to console me and understand the disappointment that I was feeling. Two, it might also mean that she would have to confront me when I felt sorry for myself or if I wanted to lash out at life not being fair.

I remember a basketball competition at the park that tested different age groups on several skills in basketball. I certainly had some natural dribbling, shooting and ball control skills that I worked hard at. I was excited for the competition and worked to be ready. I did well enough to make it past the preliminaries and the semi-finals to be accepted in the final group. If I remember correctly, I placed third. Had I placed first I would have remembered it more clearly. By placing third, I was disappointed as I believed I was better than that. My mother sensed the disappointment, and as a great coach does, she consoled me. But also how a great mother does, she wanted to take me through a lesson. My mother saw and knew the hunger that I had to be better, to compete, and yes to win. As a great mother and leader she wanted to build that into my character because she knew I would need it in life. The mother in her would state how proud of me she was, but the leader in her would tell me that it is okay to hurt and feel disappointed. She knew that by allowing me to understand that hurt and hunger together that I would build a desire to succeed. Like a great coach she knew that by not winning, and by not being told that no matter what I would earn a trophy, that I would understand life.

Does everyone really get a trophy? I ask this because in business I have witnessed employees that display a lack of accountability. Much like the coach of my teams, I believe that we as coaches need to lead our teams and develop our players. This starts with a game plan, which today is the vision of the business. We must share this constantly and point to progress. As a coach, we must be honest, especially when things are not perfect or where they need to be. But that vision is important.

In addition, as a coach, if you give me every bit of effort I will give you every bit of patience. I will instruct you, correct you, and give you my time. However, as a coach, I will look to see if you are taking the coaching and implementing what you were instructed. There is a difference in giving the effort and still having difficulty than simply wasting my time. As your coach I will reward you for progress and as you develop you will earn my trust and earn more playing time. As a coach, I also want to win.

Does everyone really get a trophy? I ask this because over time as I coach I must manage my energy and focus my energy where it makes a difference most. That might mean less energy for some players. In business I want my players to see that it is not about playing favorites because I like you more, but it is because good players have earned more rewards through their behaviors and yes, their results. Unfortunately it is not about dividing everything equally. As I coach I have a responsibility to our owners, our shareholders, and yes, the other players. To be responsible I must make every effort to keep the team winning.

Does everyone really get a trophy? I ask this because sometimes some players just have more talent. Some players are gifted. I was frustrated that everyone grew taller than I, because I loved basketball. It just isn't fair, but it is life, and nothing prepared me better for that than by not winning a trophy.

Does everyone really get a trophy? Not according to my mother. Because she would tell me that the answer really is, not everyone earned a trophy and the rules are understood from the beginning.

G) BE COURAGEOUS

Courage is a big word. It is a word that my mother truly wanted me to understand. My mother knew that in this world we must have courage. But she also knew that others may have a distorted view of courage and a distorted perception on how we should demonstrate courage. It was important to Mom that we understand what her definitions of courage were and what her perceptions were. Great leaders take the care and initiative to teach before the lesson ever comes. Mothers instinctually know the needs of their children and the timing of those needs. Great coaches have great instincts.

In the late 60's and early 70's we did not have the quick reference of the internet. I remember the World Book Encyclopedia man selling us encyclopedias that had to be updated every few years, if not every year. It is amazing how quickly information is exchanged in today's society and I laugh when I try to imagine how today's youth would react to how it was back then. In a sense I guess that it is all relative. I bring up this fact because when my mother wanted us to learn lessons and define a word she would have us go grab the dictionary or an encyclopedia for that topic. She would then have us come to her and she would have us turn the pages to find the topic and the page of reference. My mother knew naturally what we all learn as the term, "Give a man a fish and feed him for a day, teach a man to fish and feed him for a lifetime." Some leaders just have that natural instinct. I credit mothers, like Mom, as great leaders.

As we looked up the word courageous, we found several definitions. Courage: the quality of mind or spirit that enables a person to face difficulty, danger, pain, etc., without fear. Great definition, but there were others. Courage: the ability to do something that you know is difficult or dangerous. Another great definition, and this one would break it down even more and explain that it may be an encounter of facing something difficult or dangerous. Courage: the choice and willingness to confront agony, pain, danger, uncertainty or intimidation. This

showed and demonstrated that one may have to face and endure pain and agony, or that courage might have us facing intimidation and by facing up to the intimidation that we are showing courage. Mom knew we would face many definitions of courage in our lifetime, so teaching us early, teaching us constantly, and teaching us in times of need was what she did as a leader. Naturally, she would make every effort to teach us constantly, early, and while we were growing and developing. But as life occurs, many times she would have to teach us in the moment.

I believe that fear is a natural human element. So the definition that says courage is facing something without fear may be one definition, but Mom would also teach us that courage is facing something despite the fear. Because by facing it, several things could occur. One thing is we could determine that there was nothing to be afraid of. In the very early years this was most of the ways I needed to show courage. By facing the fear I addressed it, understood the circumstance of it, and overcame it through courage. The courage educated me and enlightened me. Another thing we would learn by facing our fears with courage is the true weight of what we might be fearing. This allowed us to break it down into simple terms and even though the circumstance may have been difficult, the courage allowed us to endure and to teach us, that we can endure, and that we can endure through longer periods. One of the final things that having the courage to face our fears can have is the experience that even though it may at times bring difficulty and have us go through uncomfortable things, that the experience gives us perspective to look backwards and realize it may not have been as bad as we feared. That the good Lord always seemed to get us through. Courage that I can't imagine the measure of which a mother has to have, to bring children into an unknown future and to devote their life to their children through all the joy and pain that life will provide. To me, that is true courage.

Courage, as my mother would teach, can have misrepresented or misinterpreted definitions. As I grew, sometimes a friend would challenge me to have the courage to do something and push me into

action when it really was not courage at all, it was stupidity. Here is where my mother would talk about common sense. She would teach us to utilize discernment in understanding the difference in things like courage and in the need to being accepted by friends with the need of being safe and smart. In my later years she would talk about logic and common sense. She would explain that each were different and that in life sometimes logic and common sense do not come together at the same time, or at all. As a leader we owe it to those we lead to do the same as Mom; teach definitions, redefine when needed, or when a circumstance occurs, correct and coach as you point to examples.

Mother was a woman of faith. In the Bible it is said that courage is listed 366 times. I heard a pastor say that there is one for every day of the year and one extra to hold on to. Mom wanted us to learn the courage taught in the Bible with examples of David and Goliath, which is a true lesson on facing your giants, as we all will have many in life. Fear can be paralyzing and unless we face the circumstance despite fear we will not learn that we can conquer. Mom wanted us to know that we are conquerors. I remember how she loved the Bible stories and especially the classics like the Ten Commandments. She had an affection, or so it seemed, for the stories of Joshua (or maybe it was John Derek who played Joshua in the Ten Commandments). Whatever it was, it instilled in me to understand, build and have courage, and in honor of her and for the Lord, I have a sign that proclaims, "But as for me and my house, we will serve the Lord." Mom wanted us to understand that faith can build courage and she had faith in our Lord. A great lesson for us as she led.

Is business any different? Should we as leaders not define courage to our teams and those individuals that we mentor? Like my mother, should we not desire that those we teach and coach about courage will grow, understand, and then challenge themselves to face those obstacles and become stronger from the experience? If and when disappointment happens or setbacks occur, we as leaders must teach that despite that setback it is much better to have made the attempt, faced the fear, and learned from the disappointment and experience so next time we may

plan better or attack sooner. My writing is a way of facing a fear. My writing is a way to attack what is next in my life and define if I still have something to share. Leadership is taking the steps to understand our people may have fears and to teach them to have good courage, but not the courage that my mother later defined as stupidity. When we teach about courage we help our people expand their horizons and grow as an individual and then they will seek to accomplish more. Is this not a true parallel between mothers and their children, than to us as leaders and our people? There are 366 times in the Bible that courage is spoken about. To me, this defines that there are at least 366 times a year that we need to teach our people the definitions of courage and then challenge them.

H) HEARTBREAK AND DISAPPOINTMENT

I remember when one of my sons, Joshua, was 2 years of age and he was playing in the house with the other kids. You could hear the kids playing and running around as they do and someone slammed a bedroom door shut. My son had his hand in the door jamb when it closed. I was in the next room and heard him cry out and knew instantly he was hurt. When I arrived, I could see him bleeding with his pinky finger severed completely through the bone and barely hanging by the skin. Obviously this is something none of us would ever would want to see and I pray most of us do not. I immediately took the shirt that I was wearing off, wrapped it around his finger and hand, applied pressure, and held my son while my wife drove us to the hospital.

At the hospital, the staff prepared his finger and had me hold him while they sewed his finger back on. Because he was so young they believed his finger would heal and the bone would grow back together. I could tell when holding him through the sewing process that it was painful for him, and I did everything to console him. There is something about when an emergency happens that I have had the ability to remain calm and take care of the situation at hand. This is a trait that I believe I inherited from my father. They completed the process and now it was

time to take my son and family home. We arrived home and I took my son in his room to rest. The rest of the family found their way to their rooms while I pulled a chair up and sat next to my son. He was asleep and seemed to finally be resting. It was at that moment, when no more action was needed that I broke down crying because my son had been hurt. I even get a little teary-eyed today when I think about it and my son is 31 years old. It is just the experience of seeing a person that is of your blood, your very own, hurt. It brought heartbreak.

Heartbreak and disappointment are a part of life, and certainly this was a first lesson of heartbreak to me where it concerned one of my children being hurt. It was not, however, my first lesson of heartbreak and disappointment as by that time I had experienced many. In my early years, in elementary school, I remember our class taking on the initiative of learning how to square dance. Our teacher chose each of us a partner and mine was a cute, young girl named Laura, which admittedly was probably my first childhood crush. Laura was very cute, polite and we enjoyed being partners. We looked forward to when we had to practice, and as I remember the past, we were the best 2nd grade square dancers. I could not wait each day to go see and dance with Laura.

One day when I arrived at school, I anxiously awaited Laura's arrival. Laura did not show up. The teacher arrived and she did the normal things of taking roll call, pledge of allegiance, and passed out graded class assignments. "Where is Laura? I guess she is out sick," I assumed. "I guess I will have to sit out square dancing today if my partner is not here."

Soon it was time for square dancing and everyone went to the open space of the classroom where we would gather. I stood off to the side as I already assumed that I would sit out today's session. Then the teacher dropped a bomb. "Oh Mark, I have to assign you a new partner since Laura moved." My heart instantly sank. "What? Why would she move? This was my square dance partner for life!" Obviously I am not sure of my exact thoughts from that time, but I do remember the heartbreak and

disappointment. I was crushed. The teacher assigned another student, to whom I have no memory of because I only seem to remember Laura. I probably danced like a stick man with my new partner because my heart was not into it, and I was intent on being miserable. If I could not be with Laura and square dance, nothing else was worth it. I pouted and I wanted to not participate anymore.

My mother received a report of my lack of participation and motivation, or whatever they wrote in those notes they pinned on your shirt to take home. Are you old enough to remember those? Anyway, my mother came to my bedroom with concern. One leadership trait my mother was very good at was to seek first to understand, as The Seven Habits of Highly Successful People teaches. My mother had this habit and I know she never read that book, but she executed the habit brilliantly. She came to my bedroom, sat on my bed and sought out what the report was about. My mother knew each of her subjects, how we acted, and what we did when we were upset. She knew I was upset and she was also concerned about the note from school. As she sat on my bed, she touched my chin and lifted my head to grab my attention, another great trait of hers. She always made sure we were listening.

"Marcos," she stated, "I read this note that you brought home from school. The teacher is concerned because she is seeing that you seem to be showing a lack of participation, and she states that the lack of participation is mostly during square dancing. I thought you really liked square dancing?"

I gave no answer. I was just quiet, which told my mother something was wrong.

"Marcos, tell me what is bothering you that makes you not want to participate?" Silence was once again the answer.

Great leaders know their people as mothers know their children. Great leaders have great instincts as well on what our demonstrated attitude is telling them. They can sense when things are wrong, but also know from experience and from interactions on what our actions are

saying. Great leaders pursue answers because they want to confront the situation, understand it, and resolve it with a plan. My mother had these three key steps of confrontation down. She did it so naturally.

"Mijo," there she goes, with one word and a change in tone she became so motherly and loving, but she also became more focused. "Mijo, I need you to tell me what happened that is making you act this way?"

I finally showed some acknowledgement. "The teacher assigned me a new partner, Mom. I didn't want a new partner!"

"Why did you get assigned a new partner, what happened to Laura?"

"She moved, and she did not even tell me they were moving," I explained.

I think my Mom sensed the true reason for my discontent. It was not my new partner, it was that Laura moved. Whether I told her or not, she knew I liked Laura. I am sure it was probably kind of touching to her. But back to the moment at hand.

"Mijo, it is not that you don't like square dancing, or that you have a new partner, is it? It is because Laura moved and you miss your friend."

I was silent. How could she be so right? Then I teared up. "Mom, I liked dancing with Laura. I think Laura and I were going to win the contest too! It is not fair that she moved."

Mom stopped me and then she hugged me. Oh how I miss Mom's hugs today. "Mijo, I know you hurt, and I know that you are disappointed. But Laura moved, and you cannot change that. You have to realize that things will happen that will cause you to hurt. You have to realize that things in this life will disappoint you. I wish I could take all the hurt and disappointment you are feeling right now, away from you. But I cannot. I also realize mijo that if I could, it probably would not always be the right thing to do."

This caught me off guard. Why would she not take my hurt if she could? "Mom, what do you mean by that?"

"Mijo, what I mean is I want you to know that it breaks my heart to see you being hurt and disappointed. Because I am your mother and love you so much, I wish I could take that hurt. However, I know as your mother

that I need you to experience hurt, pain and disappointment, because in life you will have them. Because I know you will have them, I need you to have the experience of what they feel like, why they happen, sometimes unexpectedly, and how you react to them. Because they will happen, I need to help you through them, and not take them away from you."

"Why, Mom, why would you not just take them away?" I asked.

Mom paused, and then looked me carefully in the eyes, "Marcos, because having you go through them while I am here allows me to be able to instruct you on what to do. It is important to me that you accept heartbreak and disappointment and learn how to get through them. Each time you learn, you will become wiser and be prepared for the next one that will come. Unfortunately, they never stop, and because they never stop I need to teach you these things. Mijo, how you react and how you allow the pain to develop you, will then allow you to succeed in life and you will become a man of good character. That is what is important to me, that you become a man of good character."

Character is something my mother spoke about my whole life. She was not shy about teaching me, correcting me, and telling me her concerns about my character all through my life. This was another great sign of leadership. Leaders let you know what is important. It is not a secret. Leaders will repeat themselves constantly on the important things. My mother understood this. Our conversation continued. With her guidance I remember she made me aware that by my lack of participation, I was not being fair to my new partner, which would be unfair to me if the roles were reversed. So with this education I went back to school the next day with a better attitude. I gave my best effort and when the contest came around, my new partner and I won. Because my mother coached me through the heartbreak and pain, not taking it from me but pushing me through and allowing me to experience it, I came out a better boy. My mother was pleased. Thanks, Mom. For the lesson that was more important to you was for me learning how to learn from the heartbreak so that I could become better prepared for the next instance.

Is this not what we do as leaders with our teams and individuals? We teach them to strive, but we teach them to learn from the heartbreak and disappointments. Did we lose a big deal or client? Did we not get a promotion or a raise? Heartbreak and disappointments occur, and a great leader will coach their people through the lesson, so their students will learn, develop, and become better prepared.

CHAPTER 2

The Pre-Teen Years – The Challenges of Life

A) EVERYONE IS A TEN

Respect is a common word that we hear so much about. But sometimes I believe it is has become so common and that we use it so freely, that perhaps it has lost its true meaning. Merriam – Webster defines respect as: a feeling or understanding that someone or something is important, serious, etc., and should be treated in an appropriate way. This definition of respect shows how it can be part of our value system and if we live this value, we not only show ourselves respect, but also others respect despite our differences.

In my early years, I had a group of friends with whom I hung around. This was in Junior High School, so we were not too old, but we began to believe in our own press that we were the cool kids. I believe that what you believe about yourself will determine how you carry yourself, and this certainly was true with our group as we thought we owned the playground. Two of my friends were big and tall for their age, so this added to our own myth that we were invincible and cool. We wore the cool clothes, or so we thought we did, they actually looked funny when I look back at pictures. But we were selective on who could be our friends and who would be allowed to be part of our group.

One day I was home on the phone talking to my friend. My mother was making something in the kitchen, but I did not realize I was speaking loud enough that she could hear or if what I was speaking about would even be important to her. Little did I know that what I said, at any time in my life, and how I said it was always important to my mother. Leaders, like mothers, know that what comes from our mouths are the very foundation of our character, and once again, character, my character, was important to my mother. So in my conversation, my friend and I were talking about this new kid that is attempting to hang around us and become part of our group. My mother overheard the conversation on how we were playing games with this kid when all along we knew we did not want him to be a part of our group. My friend and I were laughing back and forth on the phone on what we were doing as well as what we were planning to do. My mother listened as we used words like "goofball" and "dork" to describe the boy. My mother then caught my attention and stated, "Marcos, you need to get off of the phone." I hung up the phone.

I could sense my mother was disappointed, but I really did not understand yet why. She asked me what I was talking to my friend about and I tried to answer vaguely, like it was no big deal. As I attempted to walk away, my mother summoned me. "Marcos, come and talk to me." I turned back and met her at the kitchen table.

"Marcos," she said, "I overheard your conversation and it sounds like you are playing games with someone's emotions."

"Oh, Mom, it is just a new kid that keeps trying to hang around us," I stated.

"So what is wrong with the new kid that you want to play games with him instead of just telling him truthfully that you have enough in your group? Or, what makes your group so special that having him join would change it?"

There it was, my moment of truth. My mother, the leader and coach that she was, confronted issues quickly, like all great leaders do. She then had a way of walking me down a path that brought out what she already

knew, but wanted me to say it so she could address it. Great coaches and leaders have this ability. The ability to draw out in conversation the subject matter of the lesson we need to learn. Leaders know that it is more effective to have those they are teaching and correcting, to speak of the subject and the issues so that they can tie the lesson around that. My mother was a master of this concept.

"Marcos, please explain this to me and answer my questions."

The moment. By my mother's questioning techniques, she brought me to the moment of giving me enough rope, figuratively, to either save myself or hang myself. It took me a long time to learn how she did this, but also why she did this. But my answer was stating something derogatory about the young boy, and my mother stopped the conversation and my speaking immediately.

"Marcos Antonio," she said. "I will not allow you to speak like that about other people. How would you like to have someone speak like that about you?"

I tried to answer, and rationalize with my response, with the foolish belief that I could convince her that it was true, and that it was okay for me to say the comment.

"Marcos Antonio," she said more sternly.

I froze, hearing my mother say my first name with my middle name in Spanish meant it was time for me to listen, because a lesson was coming.

"Marcos Antonio, that boy is a ten, just like you are a ten. On a scale of one to ten you both are a ten, just like I am a ten. God does not make mistakes." My mother was a person of faith and raised us in the faith as well. So she stated that it was important to her that I understand that my significance is that I am a child of God and if I truly realize that fact then I will be able to face things in life when others do not treat me as a ten. But because I am a child of God, I am a ten, and no one can take that away from me.

Yes, my mother was a great teacher. I started treating others better even if some others felt that they were awkward or not gifted in the sport we were playing. As I have grown in business, I realize what a valuable

lesson my mother taught me. 'Everyone is a ten' has allowed me to help teach other leaders this aspect, and as we demonstrate this we create a respectful environment.

'Everyone is a ten' has helped me realize that we will have employees in our business that may not have the natural gifts that others may have, and they may not succeed. However, because they are a ten this does not change their value as a person. If we treat them as a ten and they just do not succeed they still have their dignity and respect. Yes, everyone is a ten.

We teach this in business, that everyone is a ten. We lay it down as a value that is very foundational and we demonstrate it daily. Because we teach this and treat our employees as a ten, they appreciate that they are respected. But more importantly, those that may not have been successful with us, leave with dignity and respect. Because we treat them appropriately, some move on to other companies and have become some of our best clients. Others refer potential employees to us for consideration, as they know what type of person would succeed. Because we treat everyone as a ten, we build a culture that is respected back when someone leaves.

Mom, thanks for the lesson. I will make sure and give the effort to personally treat everyone as a ten. I may not agree with them on many things. I may not share their interest or beliefs, but they certainly are a ten.

B) THERE IS NO "I" IN TEAM (BUT THERE IS IN ACHIEVEMENT)

As a young person, playing sports, we always heard about teamwork. Growing up, the three big sports were baseball, football and basketball. I played all three, and I was okay in all three. We would practice, and each of us had our favorite positions that we competed for, with some of us being a little more skilled in those positions. The hunger we each had to compete could be seen and the patience shown by the coaches was appreciated. They definitely had the best interest of the team at heart, or this is what it seemed like at the time.

As time went on, there would be streamlining in who would be the best possible fit for each position. The coaches would narrow down the selection with a few of us competing for the same role. Back then, and for the most part, the best skilled person won the starting position. Certainly there was disappointment if you were one of the ones not selected to start. But this is where the coaches would work us out at the positions in practice for us to improve our skills so we would be ready when called upon to play. The games would be played, the starters would start the game, and the coaches would at times rotate us in to play based upon the circumstance of the game, and the need at the moment. At times, if we were far ahead of our opponent, the non-starters might see some extra playing time. We were taught that the first objective of the game was to win, and to build and coach a team that can win.

As I grew into a young teen, sports became much more competitive. The desire and focus were for the team to succeed. The best at each position earned their starting roles, but the effort to rotate other players in was not always the focus. If it was a tight game, the starters stayed in. At times, this may have frustrated some of us players and many of the parents who wanted to see their child play. If I earned a starting role, I enjoyed and gave every effort to excel at my opportunity. I did not ever to want to come out of the game. Of course, those not starting wanted the opportunity to play a role.

There is no "I" in team. That is a statement I have heard all of my life. I believe I hear it more today than when I was younger. In today's society I see where there is a push to allow every player to play and to play their fair share. There are arguments and beliefs on which is better. Each side believes they have valid arguments on why everyone should get a chance to participate or why learning that only those that excel in their role earn more time. I am not here to solve that argument. I can only speak to the facts of how I was raised and how it affected me.

I remember playing a game, where I was on fire, which meant I was playing very well. It was a basketball game and my shots seemed to be going in wherever I aimed. We played well, and we won the game. After

the game one of the other players made a comment that I needed to allow him to shoot more, and not take all of the shots myself. However, during the game the coach saw that I had the hot hand and kept calling the plays to go in my direction, as he wanted to take advantage that I was excelling at the moment. I had the "hot hand" as we called it. So the comment by the other player confused me, and yes, maybe even hurt me a little. He mentioned that there was no "I" in team, and that I was a ball hog. That night's victory did not seem so special at that moment.

When I arrived home my mother asked how the game was. I said we won. She then asked how I did. I told her how many points I had scored and she seemed even happier for me, but she noticed I was a little dejected. She then came to my bedroom where I had walked away to and confronted the situation.

"Marcos, what is wrong? You seem unhappy?" she asked.

"Nothing, Mom, just some other player said something that bothered me," I stated.

"What did he say, mijo?" she pushed.

"He said I was a ball hog, and reminded me that there was no "I" in team."

"How do you feel about what he said? Does that match the circumstance of the game?"

"It kind of let the air out of my balloon, Mom. I was excited about us winning and I was happy that I had a good night. Should I feel guilty that I had a good night and that the coach kept pushing it my way because of that?" I asked.

"Mijo, it sounds like the coach recognized that you were having a good night and wanted to push it that way for the best chance at winning. This is the choice the coach had, and he did what he believed was best for the team. I am sure the other players heard the coach giving the directions or you wouldn't have had the ball come your way so much. Correct?" she asked.

"I would assume so, Mom. It wasn't just me not passing it around, and the plays were called my way," I answered.

"Mijo, let me help you understand something. There is nothing wrong with you achieving yourself, especially when the team wins and your achievement was a part of it. But also understand, that even if your team loses I still want you to strive to achieve. If the coach calls the ball your way, do your best with the opportunity. Mijo, it is true that there is no "I" in team, but there is in achievement," she explained.

This was something new. Maybe my mom just thought of it and it sounded good, but it certainly gained my attention. She went on to explain more.

"Mijo, in a team sport you have to trust the coach to define how he wants the team to play. He is the coach and you follow his lead. The coach is the one person that has to have the best interest of the team in mind when coaching. If he happens to think that you are the best option, then I want you to achieve. You think the coach wants you to achieve?" she asked.

"Yes, I do. That is why he called the play, Mom," I answered.

"Then why feel bad about having a good game? The coach made his choices and when given the opportunity, you achieved and helped the team win. This satisfies both areas, son. The coach decided what was best for the team, and you achieved when that choice happened to be you. That is what is expected of you. Mijo, do not get the phrases confused, because there is nothing wrong with your individual achievement. I want you to achieve at any opportunity given you, so never let that slow you down," she finished.

I sat in silence. What my mother had stated was so wise, which I know my mother was. She took a moment that she recognized something was wrong, and as the leader that she was, she utilized it as an opportunity to coach. Not only did she coach, but she took advantage of the opportunity to instill in me that there is nothing wrong in achievement, personal achievement. This may have only been a basketball game, but my mother knew that what she was teaching me is what she believed was important for me to learn in life. She knew that in life there would be challenges and she wanted to prepare me for them.

As the years went by, this comment would surface again. I remember discussing with my mother about a promotion I received and another worker was discontent. They had been there longer and believed they were entitled to the promotion because of their tenure. The situation was uncomfortable to me because certainly I wanted to excel and do my best at what opportunities were presented to me. Here is where my mentor, my mother, reminded me again that there is no "I" in team, but there is in achievement. She once again walked me through the lesson that the coach, who was the department head of the business, made his choice by assessing what was best for the team. The expectations of me was to always do my best with any opportunity and to achieve.

In business today we as leaders need to coach to this very factor. We strive to build a team culture that excels as a team. But we also must define and even expect individual achievement, and reward for it. My mother pointed out that a team with high achievers usually set the example for the team and gives the coaches good examples to point to. True leadership is building strong teams, but also recognizing and rewarding individual achievement.

C) SHORTCUTS GET YOU LOST

Life mirrors business in many ways. As leaders in a business, we should recognize and teach to these examples. One such example is to teach our employees that shortcuts get you lost. I further define this by explaining the dangers of a shortcut. Many times, because someone takes a shortcut, they actually cost more time because they end up lost and have to backtrack to the point they started down that shortcut. Other times, they do not admit they are lost, and they wander further down their chosen path and believe they have found their way, but they fail to recognize they are not at their full destination. Then finally, the ultimate danger of a shortcut is the appearance that it worked and therefore that individual learns the bad habit of a shortcut, and at some point they will learn that shortcuts get you lost.

I tell a story about when I was in elementary school back in Lakewood, California and the path I would walk home from. Now I know we all have heard stories about walking long miles in the snow from our parents, but our walk when I was young was truly about a 2-mile walk. I will say it was a much different and safer world in those days, or it certainly seemed like it when I think on the past. Anyway, as the story goes, I would always witness other kids who lived on my block take a shortcut through a wooded area and somehow they would arrive home earlier than I did staying on my route. I was always tempted to take that shortcut, but I never did. Until that day. If I remember correctly, there was something on TV that I wanted to see, so I wanted to get home earlier. So that day I decided to take that shortcut. After all, it seemed easy enough and the other kids were doing it!

So I attempted the shortcut. I went into the woods and I tried to find my way that would get me home earlier. Instead I would get all turned around. Soon I was afraid and I was lost. So, I had two choices. First choice was to keep trying, but I might get lost more. The second choice was to backtrack the way I came into the woods and go out the way I came in, and then I would be back on my expected path where I went into the woods, and walk home from there. That appeared to be the safest choice.

I will say, once I made it back to the original pathway, I felt relieved. At least from there I knew the way home. So I started back on the correct path home, but obviously I was well behind on my expected arrival time home. The relief I had from making it back to the path turned to worry as I continued on my way because, I knew my mother would be worried and would wonder what took me the extra time. Oh yes, and my father was the ultimate disciplinarian, especially when we strayed from what was expected of us. Yes, I arrived home to a worried mother who was at first relieved and then she was disappointed at me when I explained that I tried a shortcut. She explained that I had to understand the danger of my decision, because had she gone looking for me she would not have known where to look. That was the additional danger of taking a

shortcut, others did not know your path. Yes, I was certainly disciplined later when my father arrived home. Sometimes just knowing my father was coming home to discipline me was punishment enough. Telling my father was important to my mother out of respect for him, but she also wanted us to always understand that telling our father was part of our discipline. Disappointing our father is probably the same feeling of our big boss knowing the circumstance in business. By nature we really do not want to disappoint people, in business as well as in our personal life.

Funny, but I had many lessons about taking shortcuts while growing up, as this was not the last one. Each time I received correction from my parents, but the best part was my mother always explained why the decision was poor and utilized pertinent examples for me to understand. The biggest lesson my mother wanted me to learn was that sometimes by taking a shortcut I might have success and by having that success the habit of taking a shortcut might become common practice. She taught me this lesson further when I was in Jr. High School and I formed the habit of procrastinating on large homework assignments. I had success and the belief that I had the ability to cram and do the assignment at the last second, work hard the night before, get it done and receive a good grade. By taking this shortcut and having success, the habit of procrastination set in. Finally, I had an assignment that I procrastinated on and the night before it was due a family emergency occurred, which made the ability to get my assignment done impossible. I thought my mother would write me some type of note explaining to my teacher and excusing me from the assignment. My mother would not write me a note, as she knew I had plenty of time to complete the assignment and had warned me before that this would come back to bite me. I had to face up to my teacher, who was disappointed in me because he knew I had the intelligence to succeed. But my teacher also held me accountable.

As stated before, my mother was the best leadership coach who chose to be a housewife. Coaching, teaching, and using pertinent examples are what we must do when we encounter the same situations when employees and managers take shortcuts. Whether it is a shortcut

in a sales cycle, or a shortcut in proper business planning and execution, each have the same dangers. It is imperative that we as leaders provide roadmaps to success and teach to them constantly. We owe it to the growth of our people and our businesses to teach that shortcuts get you lost.

I have seen leaders take shortcuts for the quick gain. Then, as Mom stated, the danger is that perceived success of the shortcut created a habit of shortcuts. Eventually and always, someone, or something gets lost, and that business has to back track to where they took that shortcut and start from there. The danger in business is, by getting lost you have brought so many other team members along the way, and your team is disoriented. Several people are lost and people suffer, performance suffers, and individual careers are at stake. It also becomes difficult to point back to what was the shortcut that caused poor performance and others are held accountable. We have a great responsibility to recognize the difference of a shortcut or a well thought out plan.

One of the most important factors on shortcuts, is to never sacrifice your corporate values in taking a shortcut. If it involves sacrificing your corporate values, then this should clearly alert you that this is a shortcut. I have seen businesses make unethical decisions for quick gain, and although that quick gain might have been achieved, their employees know that ethics were crossed and now know the corporate values mean very little.

D) JUST ENOUGH ROPE

Great leaders must be experts on psychology, or at least it seems that way. I know my mother appeared to be an expert in this area, but I personally know she carried a normal High School education. So I now understand that great leaders have great instincts and an ability to read their subjects and know how to teach and coach them effectively. Great leaders also have methods to teach and to define their subjects. Mom was no different. Mom explained one of her methods, as she was not shy about it, but wanted us to learn from it. This method she labeled, just enough rope.

Sometimes we just do dumb things. I do not know why we choose to do them or why we sometimes do not think before we do them. It just seems to be a part of growing up. We sometimes just do dumb things. I remember one time when spending the night at a friend's house, and my friend, his brother and I somehow had the idea that it would be fun to throw eggs at the neighbor's house across the street. We started throwing eggs and celebrated when we hit the house. When one of us hit the house squarely, we somehow became braver and boldly walked closer to get better shots. Then one of my friends thought it would be fun to hit the neighbors' car parked in the street. We believed we were justified because the neighbor's house that we were attacking did not think highly of us anyway. Maybe they had good reason. The night seemed fun and we felt brave without thinking that we were doing was wrong.

Just enough rope. A great lesson, and this was only one of many examples, that my mother utilized the tactic on me. I arrived home the next day and my sister reported that the neighbor's house, and even their car, was attacked with eggs. "How horrible," she exclaimed that someone would do that. Naturally, I acted like I did not even hear the conversation. I grabbed a glass of Kool-Aid from the kitchen, calmly drank it down, and put my glass in the sink. Funny, but in our younger years we believe we are great actors and that we can play things off from what reality was. But Mom already knew. Mom was already watching me, my actions, mannerisms and facial expressions. You see, we believe we could act so innocent, but that mere act automatically demonstrated we were guilty of something, and mothers know. So I set down the glass and casually started to walk away.

"Marcos, what do you know about the neighbor's house being egged?" she asked.

"What neighbor?" I answered so innocently. Of course I acted like I did not know.

"Marcos Antonio, come here and talk to me," she exclaimed.

Now a tense moment. Why does Mom want me there? What does she know? Did my friends already spill the beans? Did someone see

us? All this raced through my mind. When you have done something wrong, the unknown about what is known is what scares you. Mothers know this, and it is a tool in defining the truth.

"What?" I answered, like I was annoyed and somewhat tired.

"I want to know what you know about the neighbor's house being egged, as well as their car," she stated.

"What would I know?" I answered so innocently.

"What is it you did at your friend's house last night?" she asked.

"Nothing, we just watched some TV," I answered. I tried to answer vaguely, because I believed giving too many specifics would be a dead giveaway. I thought I was a genius. But in reality I was never smarter than my mom.

"Marcos Antonio, I want you to tell me the truth! What did you boys do last night?" she asked in a stern voice.

"Mom, we did nothing. What are you getting at? Are you accusing us of throwing the eggs? Why do you always want to blame us?" I answered. I thought this was a great tactic. Let me turn the tables and make it seem like I am the victim. Perhaps this will make my mom stop asking, or she might feel guilty.

The conversation went back and forth for a little while. Each time my mother would ask a question that would tie down the circumstances a little more. She would push the conversation further down the path so that by her questioning technique, she would catch the conflict and the changes in my answers. She would ask the same questions, but in a different way and my answers would start to be inconsistent. This is what my mother meant by just enough rope. By her questioning, she would give us just enough rope, a little bit more with each question, that we could use the rope to hang ourselves by lying deeper, or save ourselves by being honest and confessing. Mom was good, and she always wore us down. I confessed to the egging of the neighbors. Little did I know that my friend's mother had noticed she was missing almost all of the eggs in her refrigerator and she had also heard about the neighbor's house being attacked with eggs. It was an easy assumption to believe that we

were responsible, and she reported it to my mother before my arrival home. Mom just had the patience to walk me down her leadership lesson of just enough rope. I failed the lesson this time, and I was punished appropriately.

A few days went by of my restrictions, which my parents always made sure that whatever the terms of my punishment, that I served every bit of it. By suffering all of the determined and defined consequences of my actions, I certainly learned that every wrong action would have a consequence. This was my mother's way of working on shaping my character. Good character was important to her. As I grew in age, my mother would then explain her tactic of just enough rope. She explained because one time I finally came out and asked her, if you know already then why all the questions? Mom explained that she wanted to see how far I would try to carry a lie. She explained that the more I would carry the lie forward it would disappoint her more. Leaders explain disappointment factually to those they lead. Mom would always let me know what would please her and what would disappoint her. Mom then further explained that she would ask more questions and that it was my decision how much I wanted to lie, or how much I would be honest, and that both had consequences, but at different levels. She stated, "Marcos, each question I ask is designed to give you just enough rope. What you do with that rope is up to you. You decide with your answers if that rope will hang you or save you. How you choose is up to you. I pray that over time you will learn that being honest, even if you did wrong, is a better option."

Over time my mother was correct. I saw her tactic of just enough rope mold me and test me as well. I remember instances of breaking a neighbor's window, by accident, but also by doing something dumb. My first instincts were to run, but then I quickly took responsibility, went to the neighbors and let them know that I was the one responsible for their broken window. I helped them clean up, even though they were angry at me. I apologized, and yes, my parents paid for the replacement, and I was still punished. But my punishment took a different tone. I still

had instances where I did something wrong, but learned to confront the situation, take responsibility and accept my punishment. At that moment, it seemed when we reacted this way, our character then changes us that we are harder on ourselves than others can be. I believe this is where my mom was leading the lesson of just enough rope. Self-accountability.

In business, just enough rope is a great tactic. Certainly we can just come out with the facts and address the issue. But a great leader and coach will utilize just enough rope to define and understand the character of the individual team members. Then, like Mom, that leader will confront the issue, assess consequences, and then explain the tactic and why it is important. Just like Mom, a great leader will explain that good character is an important factor to them and that those that use the rope to save themselves would be trusted more than those that always find the rope is hanging them. Those of good character may still make bad decisions, but using the rope to save themselves will allow them to earn trust, receive help, and be given more responsibility. Have you been given just enough rope?

E) BAD NEWS DOES NOT GET BETTER WITH TIME

Bad news does not get better with time. This seemed like the perfect add on to just enough rope and it is not by coincidence that my mother emphasized this lesson to build upon just enough rope. Just enough rope was the true test on whether I would admit to wrong doing when questioned. Bad news does not get better with time was the next level of true character, the test on whether I would bring bad news to the forefront before having to be asked about it.

I am sure it took many lessons of just enough rope to learn how to utilize the rope to save myself. The important thing to understand about using the rope to save myself is that it did not always mean that there would be no consequences. The very nature of a bad decision brings consequences. That is something my mother wanted me to understand. But she taught me that the benefit of using the rope to save myself

brought me to the point where others would help me, and I could learn from the experience. After all, if we always got away with doing wrong that would lead us down a dangerous path. But now Mom is challenging me with bad news does not get better with time. What does that even mean? Mom wanted me to understand that things would happen that were unwelcomed things, and sometimes even bad, or what we call bad news. Disappointing things would happen, things would break, by accident or by natural wear and tear. But Mom wanted me to know that when bad things happened it was important to her that I learned to communicate it and not hide the news. Even if I believed I would face consequences and punishment, Mom believed and taught that no one is ever eliminated from the prospect of making a mistake, a bad decision, or just encountering bad news. But a person of good character, when faced with that circumstance, would not hide the news, but they would communicate the news no matter how serious or harming it could be. This probably became one of my mother's top tests of character, to see if we learned and lived by the fact that bad news does not get better with time. What the statement really says is that bad news is bad, and no matter at what time others find out about the news, it was going to be bad news. So hiding the bad news did not make it better.

There are probably so many stories that taught me the lesson of bad news does not get better with time. My parents had the old fashioned television with a built in stereo with the record player that played LP's and 45's. I remember how fancy I believed those were and how lucky we were as a family to have those. The LP would play in different speeds and we thought it was funny and cool to play some of the music fast so the singers would sound like mice singing. Mom did not like us to play around with things that were not in the manner in which they were designed, but we would sneak and still do it at times and it seemed harmless.

Mom loved listening to her music early on the weekends and she would play it turned up. She loved Vikki Carr and would play her music so loudly. She had other favorites like Teresa Brewer, but Vikki Carr really seemed like it was her favorite. Now Dad, he loved Frank Sinatra,

Dean Martin, Sammy Davis Jr., and the likes of Roger Miller. "King of the Road", "My Way", and "Everybody Loves Somebody" are songs I can still hear playing and my dad singing along to. My favorite memories are when they would allow us to play some of our music and the family would gather in the living room and dance. I can still see Mom and Dad dancing. It is a fond memory of growing up; their music, their dancing, and my father's solo dancing, swirling his right hand in the air while he wiggled his hips and moved backwards. I can still imitate the dance today. How I would love to experience that moment just one more time.

I remember back in those days we would also have albums that would tell stories or sing funny stories. I can still remember I had some Mighty Mouse story albums that would tell a story and that story would be full of drama with the background music emphasizing the moment in the story. I may have heard those stories a thousand times, but there was always the joy of the next time.

Soon my brother and I realized that by playing our story LP's on Mom and Dad's stereo, instead of the ones in our bedrooms purchased for us, allowed us to alter the speeds and make the music or the story sound funny. I remember there was a story with a firetruck and changing the speeds made the siren and the voices comical. It wasn't long after that we learned that we could change the speeds mid-stream and then change them back again making the LP all the more comical. The more we would play with their console, the more we would experiment with what we could do. Finally, something went wrong. Something happened to the needle that would play the music. Perhaps we put pressure on it or just flipped it over too many times, but the needle made the music sound bad and it would get worse the more we would play our album. So we did the first things any preteen boys would do. We closed up the stereo and told nobody. Perhaps we hoped it would just play okay next time somebody tried it. In reality we probably just wanted the next person who would play music on the stereo to believe that the needle went out on them. Make them believe they had something to do with it. Yes, we thought silence was the best option.

Then it came, Saturday morning. It is funny, but in just a few short days my brother and I may have forgotten about the stereo. A few days is a long time when you are young. But bad news does not get better with time. Which really means that bad news will always come forward and present itself. When it does, the more time it takes for that bad news to be found out, it is worse, not better. Oh yes, my mother went for her favorite music, and the music sounded terrible, unclear, and then scratched. When the music started acting up my mother attempted to adjust or fix it, which made it worse. The next thing that happened is the needle apparently chipped or was damaged, which then scratched the album my mother was playing. She was upset. We were frightened. Perhaps Mom would believe it was something she did, we thought. Unfortunately we were not so lucky.

Stage two, Dad was home, and he did not like it if Mom was upset, especially if it was because one of us messed with something of hers. Dad was always protective of Mom, which I feared then, but appreciate now. I think when my dad hollered for us, I pretended I was asleep. But then my dad used those words, "Don't make me come and get you!" which pretty much made us hop out of bed and run to him. Dad was a disciplinarian, and his look when he was angry would bring me to tears. My brother and I were there in the living room by the console and my dad wanted to know who played with his stereo and damaged the needle. We both stood silent. I am sure my brother, Bob, and I might remember the circumstance differently, but I remember him denying anything and I just started crying. I knew we were caught and I did not like my dad mad at me. Worse yet, I feared the punishment. I knew we did wrong.

I don't remember the punishment, but I remember this instance as it is my earliest memory of bad news does not get better with time. I remember later telling Mom how sorry I was as she brought me close to her. She had me lean on her leg as she sat down and grabbed her Vikki Carr album. She slid the album out and showed me the scratches. She said, "Look mijo, my album is scratched and I can't play it anymore."

I knew how much she enjoyed that album, and it hurt me to disappoint her. She then explained, "Mijo, you and your brother know you are not supposed to play with our stuff, that is why we buy you your own. But what disappoints me, mijo, is that when something went wrong, you tried to hide it and you told no one. Because you told no one more damage occurred as it ruined my album. Mijo, bad news does not get better with time, it will always be found out. The quicker you bring the bad news to others' attention the better, even if you are the guilty party, the better for all. Had you told your Dad and I, we would have bought a new needle. Now, it became worse as we need a needle and a new album. I want you to learn and to have the character to bring bad news to the forefront. That is the man I want you to become, okay?"

I nodded my head with tears as I felt like I broke my mom's heart, but she forgave me. It was the lesson that was paramount and important to her. As the years went by, I was tested even more and even when I had my first car accident or damaged one of my father's tools, I brought the bad news forward. I have learned this in business and it is an important lesson to teach. Thomas Henderson, the former Dallas Cowboys player, teaches that the true test of character is if you do the right thing when nobody is looking, as it is always easy to do the right thing when you are being watched. Bad news does not get better with time is the parallel to that statement because it will always be found out and not saying something can possibly bring more damage.

As a leader, like Mom, when I experience bad news in business that I find I must teach the lesson and give that individual that I am leading an opportunity to understand and an opportunity to grow from the experience. We lead, we coach and we mentor, and we shape the character of the future leaders of tomorrow.

F) SUCCESSFUL PEOPLE SURROUND THEMSELVES WITH SUCCESSFUL PEOPLE

Why does this seem so hard to understand? Yet, we struggle with the philosophy and different points in our life. Growing up, I always

struggled with the idea that who I surround myself with is more than likely who I will become. Mom would make that statement many times throughout my life. Certainly we all want to be liked, and in many ways we all want to be popular. But the reality of the situation finally hit me like a brick.

As stated, growing up I sometimes struggled with who I called my "friends". I had a couple good friends in elementary school that were tall for their age and I was of average height. Being tall in our preteen years seemed to give our group some clout, or a perception that we were just bigger than everyone, or at least my friends. This perception made us think we were cool, maybe even entitled to anything we wanted to do. As a group, we strayed in many ways and found ourselves in trouble many times. There were plenty of times when our teacher, Mrs. Winchester, would talk to each of us separately and try to educate us on how the others were bad influences. I disliked her for this, but as I look back I see what love and care she must have had to speak up about the situation. I remember she would tell me I was a smart boy, with a great future, and that hanging around with the wrong crowd was no good for me. I was too stubborn to listen. After all, I was popular. That is what mattered to me.

Thinking back, I remember how I really thought that we were the cool kids. No one got in our way and other kids wanted to be a part of our clique. We were selective on who we allowed in, as if it was something you had to earn. But I remember a great lesson that occurred, and my mother was there to quickly point this out, as the leader she was. Because of our reputation, and the knowledge of our mischievous ways, we were the first ones questioned when something happened at our school, even though we had nothing to do with it. At times, it seemed like we really had to account for where we were at certain times so that we would not be blamed. Over time we would find ourselves accused of everything, or at least it seemed that way.

I remember telling my mother about it, as I knew she would want to defend me. I believed in my mind that she would say, "How dare my

son get accused of things with no evidence." So I told my mother that we were pulled into the principal's office and questioned on something that occurred at the school that we had nothing to do with, and how unfair it was. I expected that she would be the first to defend me. But it was not that simple. In everything that my mother did, she did it for me to learn and to grow while developing my character. She knew that even if what she said caused me pain that if I needed to hear it, she would still say it. She was a true leadership coach and mentor who had my best interest at heart. This is a key trait of a leader, that they not only earn the right to speak the truth when confronting a needed issue, but that they believe they owe it to their subjects for their benefit.

"How can you blame them, with whom you chose to hang around with?" my mother asked.

What? This was my mother's reply? "But, Mom, we had no part in it, they just don't like us, that's the problem," I replied.

I started to state my arguments and my mother instantly motioned her hand and used those two words that gained my attention. "Marcos Antonio, you and those you hang around with have done enough mischievous things that you have only yourselves to blame. You need to learn that in life it will always be important to be aware that whom you chose to hang around with is how others will see you. In addition, it will be what you will become. You will become like those around you and you may not like to be viewed that way."

"Mom, it is not right that they blame us. I am not sure what you mean when you say it is what I will become."

Mom was cool at times, she always showed in situations like these that she had command of things. Great leaders have and develop a presence of control, and of confidence. Mom had that control and confidence when teaching.

"Marcos, you will learn that who you hang around with in life is important. This is true when you are young, and especially when you grow up. First, you will gravitate towards those you hang around with in their habits and belief system. So if you choose to hang around

with those that have a poor belief system, or bad habits, then yours will develop in the same direction. Second, others will just start judging the group based upon its lowest denominator, meaning they are not judging based upon what would be the best qualities of someone in the group, but they will judge on someone's worst qualities. As that starts to set in it becomes difficult to change that perception of you. This is why you need to hang around good individuals, who are respected and successful. When people perceive this in you because of who you hang around with, they will give you the benefit of the doubt. This is just human nature. The company you keep truly influences your character and it reflects on you."

My Mom always made a lot of sense. She had great wisdom. Over time I was cognizant of the fact that whomever I would associate with is how others would view me. As I hungered for a career and growth along the way, I quickly learned the next step. Successful people surround themselves with successful people. This is so true in so many ways. Successful people share ideas and truly desire for everyone to be successful. Successful people are giving of their time and always have an ear to listen and to provide feedback. Over time, hanging around successful people just drives your focus to the right values and principles because those around you live them each day and it is the foundation of success.

So as leaders, and in business, we need to build a group of successful people, and quickly identify those that might affect this in a negative way. As leaders, we must utilize our skills to coach that person and define if they are coachable or not. Once we define that they are not, we need to make a decision that benefits the team and protects the culture and the environment. Sometimes leaders must make a difficult decision. But if they can create a culture that allows and rewards putting successful people together, then their culture will become infectious, and people will grow and develop.

As an individual, I give you my mother's advice. Mom would state many times while I was growing up, "Show me who you hang around with

and I will show you your character." She knew our character was tied to who we chose to hang around with. So as a leader, I coach to surround yourself with successful people. Mentor others, and get mentored by others. Great leaders in business look for and hire individuals that are smarter than they are. Their focus is on success, and that is success that is built upon the right values, principles, and good character. Strong leaders will believe this concept so strongly, that they will separate themselves from the wrong situations and the wrong individuals. Successful people surround themselves with successful people.

G) BE A GOOD EXAMPLE

I like how little kids dream. To see how excited they become when they meet a Fireman, Policeman, Baseball Player, Doctor, Nurse, or whatever profession that drives their dream. It is fun to see their development and how they play out those dreams of wanting to be in one of those professions.

The other thing I enjoy is being a part of contributing to those dreams. I mentioned in a previous chapter that I sent our friends' son a child-sized astronaut suit to enhance his dream of being an astronaut. I remember in 1969 when Neil Armstrong and the other astronauts landed on the moon, and then took the first steps. Our country was mesmerized and in awe at such a seemingly impossible feat that was conquered at that moment. Oh, how I wanted to be an astronaut at that moment as a little kid.

I know that as a little kid, my dreams of what I wanted to become probably changed many times. My parents encouraged my dreams, as most parents do for their children. Parents understand that we will have dreams of what we would want to become and therefore it was important to them that we had good examples to look up to. Mom spoke of values and principles, which I mention and write about repeatedly, because Mom spoke of them over and over again all throughout my life. Mom took an interest in what my goals were and would even help

me set goals. This was her natural leadership trait, not only taking an interest, but also participating in the process. Mom's participation even taught me how to set goals, evaluate goals, and even adjust goals. Being prepared for life and for success was her goal for me.

Like any young kid, preteen, and even a teenager I had different idols and dreams, and what I wanted to become changed many times. I spoke about my childhood sports idols and how I chose good models that were great players, but also men of good character. Certainly I wished at some point in my life I could become that athlete, yet somehow I did not become Carl Yastrzemski, or Len Dawson, but I had fun doing the best I could. My mother and father always encouraged my dreams and encouraged me to believe that I could conquer and succeed. That is the best part of their love and coaching.

However, I remember in my teens as I was making that turn where the next level of maturity was setting in, as we go through many levels, with many more to come. It was at this level that my mother recognized the changes and started teaching me, coaching me, and leading me in different ways. Good coaches recognize and do this and Mom was the best. She was ready for my next lesson.

I was ambitious, and I think at some stages we want to impress, wow, and shine to others, but most especially to Mom and Dad. I was an okay student, and I developed good logic and common sense. I remember visiting my father's place of employment and being intrigued with the computers of those days, so I brought home one of the computer manuals that spoke about binary codes. This caught my attention and I had an interest in learning more. Because I was good in math, and logic, it seemed like a good future and this became the next thing that I wanted to become. But I remember discussing some choices on the direction in my life and asking my mom, "Mom, what would you want me to be when I grow up?" I know I asked her that many times when I was younger, and Mom would answer in a way that would encourage and excite a child. But this time was different. I was at the age of puberty and Mom knew the moment was right to build upon my maturing level

and she answered, "A good example." This confused me. Is a "good example" some type of job position that I am unaware of?

Mom saw my confusion, and simply said what other great mothers feel and teach. "My son, I will love you unconditionally no matter what you do. I pray you choose wisely, and that you are always safe. But what I want most, is that whatever you decide and become, that you are a good example to others. That is what would comfort me. This, I believe, is your responsibility in life. I want you to own that responsibility and I want you to live that responsibility. "

Wow, at first I thought that sounded like a lot of pressure. But as time went by, and with more conversations with Mom, I understood what she meant. She wanted me to be a good example as a son, brother, father, employee, leader, believer, and yes, even in defeat. She always said, "Others are watching, let others learn from what they see. Marcos, even if you have done something wrong, I want you to be a good example of how you accept the consequences, but especially how you correct yourself." Over time I hope each of us may realize how true this is.

So today, as I lead, I will try to be a good example to those I am leading. I will work to be a good employee, a good man and hopefully good in the other categories of my life as well. Today, if I am a good example, I have accomplished my mother's dream for me.

Leadership starts, and ends, with being a good example. When my mother saw me start to become a young manager she would always ask about work. Mom always wanted to see my growth and participate in me growing some more. I remember how she told me that leadership starts and finishes with me being a good example, and if I could start by being a good example as well as finish by being a good example, then I would accomplish the challenges in between. It is between the start and the finish that we are being observed. True leaders understand the importance of being a good example. They strive to set good examples and they are quick to correct themselves if they ever believe they missed the mark of setting a good example. This is why humility was so important to my mother, because she knew that as a future leader

humility would give me the strength to hold myself accountable and to be honest.

Leaders understand the importance of not only being a good example, but also teaching future leaders this key element of leadership. Leaders are watched and observed, and an error in not being a good example seldom goes unnoticed, but in addition it establishes a perception in others mind. This is why things like gossip among managers or managers with their team members can be so damaging. That person that sees a manager gossip will eventually wonder what is said about them when they are not around. Note I stated manager, and not leader, because not all managers are leaders and this example is one of many ways that they destroy their ability to lead. This is why my mother said, "I want you to accept that responsibility." We must teach future leaders that this is a responsibility, but it is also an honor. So today, start and finish your day with being a good example.

CHAPTER 3

The Teen Years – Importance of Decisions

A) BE MORE CONCERNED ABOUT YOUR CHARACTER

I was just starting out in the workforce, which in my days as a teenager, most of us worked in the fast food industry. The work was steady and the pay met my needs at the time. But as I started my journey with others of the working class, I realized that who you associated yourself with at work seemed important. I discovered that in a work environment, much like in a school environment that groups would form and develop with coworkers who would hang out after work and plan doing things together. Within a short time, I would evaluate the different groups, or cliques as you might describe them, and I became associated with one of them.

The choice was easy as I wanted to hang out with the cool teens that I worked with. It's funny how the groups formed in the workplace, most based upon personalities, and common interest. I also remember that everyone seemed friendly. But one group seemed to be what I perceived was the cool group. Yes, that was the rating we gave things that met a certain element of approval. Cool was good and cool was popular. That is what I wanted to be a part of. I wanted to be part of the popular group. Popular seemed important to me.

During my days off, and after work, I started hanging out with the perceived cool crowd from work. It was always nice to make new friends and I believed the more friends you could have the "cooler" you would be perceived. I was more concerned with how I was perceived. Another way to state this is I was more concerned with my reputation. My reputation, I believed, made me cool and it was also what made me popular. At least that was my belief back then. It makes me laugh sometimes when I think about it now, because being cool and popular is what I placed such a high value on.

As time would pass, and as I would be with the cool group, someone in the group would cause some mischief or do some things that would make me uncomfortable. Some of their actions crossed the line of right and wrong. How they treated certain individuals made me question if I should stay. They would belittle people, and carry on like they were above others in stature, intelligence and looks. I could feel my questioning of the values and principles that I was taught by my mother. But because I was concerned about my reputation I went along. Yes, I was a fool.

It did not take long for my mother to see a change, but also notice that I was not the happy son she knew. As I have stated before, my mother was the best leadership coach and mother, and her senses were keen, as great leaders develop their senses. As a coach and leader she recognized the warning signs, and as a coach and leader, she confronted the situation. Leaders confront, as they know hesitation can allow for more damage. So my mother questioned me, and I listened. She told me her observations and what her motherly wisdom perceived. She always could see right through me, and her perception was right on target.

"Marcos, tell me what is bothering you? You keep going out with your work friends, but you do not seem as excited as you once were," she asked.

I remained silent.

"Marcos, you do not have to tell me. But I can tell that something is wrong. I can tell that voice in your head is talking to you, and that something is on your mind."

In time I opened up to my mother about my misgivings of my new found friends. I told her about some of the mischief, and how at first it seemed harmless, but that now it seems to be getting a little worse each time. I told her about some of the belittling that seemed much more than just teasing someone. I described to her how it seemed at times that we hurt certain people, not physically but with our words. She asked, "Then why do you still hang around that crowd? The choice is simple, just separate yourself from them."

"It's not that easy, Mom," I replied.

My mother stopped me as she knew the direction that the conversation was going. "Marcos, is it that you are concerned about your reputation?"

I answered, "Yes," as I knew she would understand that. But she didn't.

My mother, in her leadership wisdom coached me to see the difference and the importance for me to be more concerned about my character than my reputation. She said, "Marcos Antonio, reputations come and go but your character stays with you. Your character is who you are as a person."

Character was always so important to my mother. Although it seemed I failed the test many times she would always bring me back to the lesson of character. Mom emphasized all through my life how she wanted me to be of good character and that others will know me by my character. My mother taught me that many people will worry about their reputation. The problem is even people of bad character worry of such. My mother stated, "Your reputation may open doors, but your character will keep you there. Mijo, you may face hard decisions, and in life you will have challenges. Difficult times happen in every life. When faced with a crisis a man of character falls back on himself. If you have established yourself with good character, you will have built a strong foundation that will get you through those hard times, and you will be a better man for it. In addition, you will then provide guidance and support for others. That is who you are, Marcos."

Thanks, Mom. I learned and observed as my character allowed me to go through difficult times. Mom, the lessons you taught me are so true, and that man of character has gained strength from those experiences and hopefully has become a better man. After all when we are more concerned about our character, what can be said about our reputation?

That is a good question. One day I witnessed a manager stand on a chair on a sales floor, as he berated the whole sales team. The team listened, but unfortunately the team was used to the belittlement. In the manager's message, was how frustrated the manager was and how disappointed he was in the results of the team because of all of the effort that he as their manager put forward. The message seemed all about him and less about them. His message was one sided, and it lacked all elements of leadership. This is why I stated he was a manager, and I did not mention him as a leader. I believe one of the reasons the manager chose the timing on delivering this message is because on that day some visitors from the corporate office were present. Apparently the day of the visit, and perhaps the current results of the business were not up to the standards needed. That manager believed his reputation was at stake and therefore made an appearance of ego to demonstrate to the team, and to the visitors, his dominance. That manager was not at that business for too much longer after that day.

Leadership teaches that character, good character, is the foundation of who one needs to be and how to demonstrate. Had that manager truly had solid character, he would have had the respect of his team and of the visitors. Certainly, as a leader you can convey disappointment on results. But even in a failing moment it is better to walk away with your character in check and your reputation never questioned. As Mom would teach this to me, we as leaders need to make this an imperative teaching as we mentor others. I have stated many times that people want to be led and that they have an innate hunger to find a true leader. I believe it is the good character of a strong leader that they recognize first. Remember, your reputation may open doors but it is your character that will keep you there.

B) THE VIEW FROM THE MOUNTAIN TOPS

What mother does not want their children to be successful? No doubt that Mom would lay down her life for her children and, in addition, would also want to protect them from all harm. I am certain that my mother wished she could take every pain and ache from me, from physical pain to emotional pain. It must hurt, as a mother, to see your son or daughter go through pain. When I encountered pain I could see the anguish in my mother's eyes and then the sorrow. Sometimes that anguish would be panicked if and when I got physically hurt as that was my mother's first reaction. I remember when I was very young and having my arm broken severely. When my friends mother brought me home, my mother said a few swear words, which was her way of showing panic. Because I saw that panic I wanted to calm her down. There I was with a severely broken left arm.

"I'll be okay, Mom. I'll go to my room," I stated.

Mom called Dad, who seemed to get home in no time at all, and they took me to the doctor's office. The doctor saw the severity of my arm and directed them to take me to the hospital. If I remember correctly I even stayed a day in the hospital as that is how severe the broken arm was. But my memory of the moment is more about seeing my mother's anguish in my being harmed.

I speak of a mother's anguish of witnessing or knowing their sons or daughters will get hurt and having to face heartbreak, but Mom knew it would happen so that leadership coach in her believed it was wise for her to teach me the lessons from each one so I would be better prepared to survive, but also better prepared to avoid them if possible. In addition, she knew hardship, pain and sorrow each had lessons that would further shape who I would become. She saw this as an opportunity to think of it as how she would present me to the world and how the world would perceive who I was. She wanted me to be a leader and she believed it was also important for a leader to help others and be an example and utilize the lessons learned from hardships and pain to help others through them.

Mom always seemed proud of me and I certainly hope I gave her many moments of that pride. I did okay in Jr. High School, won some awards and started my first two years of High School with solid grades. I seemed to have a knack for math as I enjoyed math and excelled at it. It was around my sophomore year and into my junior year that I started working. My parents did not require me to get a job, but it seemed like the right thing to do. I was good in restaurants and the spending money was nice to have. It seemed about this time, with work, friends, a girlfriend, and school that my grades dipped from what they used to be. Mom was concerned. She knew that I had intelligence and wanted me to have success. She expressed her concern.

"Marcos, your grades have dropped and you are hardly at home anymore. Are you sure that you are not making yourself too busy?" she asked.

"No, Mom, it is just the subjects are a little more difficult. Plus, I am not sure I have the right teacher anyway," I replied. The answer I gave was my own way of rationalizing, as I seemed to enjoy the busyness of my life and would not know which item I would sacrifice if I had to.

"Marcos, we do not require you to work. If you want to concentrate on school we will support you," she said.

"I know that, Mom. But I like working. I think it adds value to what I am learning as well."

"Okay, but I am concerned, because you were doing so well and that can take you far," she explained.

"I'll be okay, Mom, I know what I am doing," I answered. Certainly as a teenager I believe we all know what we are doing.

Mom knew better. She saw a dangerous trend and wanted to, and tried, to correct it. She made many more attempts and even had my father speak to me about the subject. I was stubborn and hard headed. I did not recognize the repercussions. It is hard to look that far ahead as a teenager, but Mom always did.

As the next few years went by, and as I made other choices that would have repercussions, Mom at least wanted me to learn valuable

lessons that she believed at some point would bring me through any consequence. No matter if I was going to be a Rocket Scientist or a Restaurant Cook, Mom wanted me prepared to succeed, be the best at what I chose, and have lessons to teach others. That is the true mentorship of a leader. Mom knew that we were at a point where she could not change my direction, so she made me better prepared for the direction I was headed. What a wise woman. I can still remember our conversation and her words, and like Mom, she repeated them many more times throughout my life.

"Marcos, your choices will bring happiness and sadness in your life. Enjoy the good times and treasure them. Keep your head up and have faith in the Lord during the hard times and ask the Lord, "What is it that I am to learn from this", and then listen. Most of all, never give up. Remember that life is lived in the valleys and you need to attack life to make it through. But those few times that you reach the mountain tops remember, to enjoy the view. It is the view from the mountain tops that will keep you fighting forward in the valley for that next moment on the mountain. Because you have been to the mountain top and you remember the view, you will fight to get back there again." She hugged me, and left my room.

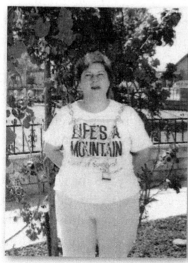

Mom, I remember those words that day and on many other days. I remember crying in your arms when facing heartbreak, and I remember sitting by your side when facing uncertainty. But most of all I remember the view from the mountain top and how I want to stay there, camp there, and not leave there. Unfortunately there are valleys, and they are difficult at times. But as you taught me I will teach others to remember the view from the mountain top.

Leadership is not always about success. Leadership is about life, which covers every emotion. In business, leadership is still the same message. We need to teach our employees how to live and make it through the valleys, and then how to celebrate and enjoy the view from the mountain tops. We need to prepare them for the inevitable trips through the valleys and how to learn from every situation. We need to teach the lesson of how to learn and what to learn. It is from our teachings that they will teach others, because great leaders pay it forward. Then we need to teach not only how to get back to the mountain top, but how to fight to stay there. Because the next thing Mom taught was to not be afraid when being moved from a mountain top because the next mountain will be much more spectacular.

C) IF YOU DID AS MUCH TODAY AS YOU PLAN TO DO TOMORROW

Growing up, my father was a workhorse and a disciplinarian, God rest his soul. As kids we would be up early on the weekend doing our chores with him. The boys did the outside work and the girls did the inside kitchen chores. This was the tradition of which we were raised. Although on Sundays, my father would bar-b-que a lot, which is probably why it is in my blood to bar-b-que a lot as well. I remember we would be up early, do our yard work and other chores and then back to bed for a nap. Of course Mom would be blasting her Vikki Carr music as I mentioned before. I believe this did teach us good work ethic and still to this day I wake up early every Saturday and Sunday out of habit.

As we made it to our teen years, we were assigned what chores we were responsible for. My father had a chalk board in the garage and he would list things to be completed by each of us. Most of the time there was no time frame other than the expectation that it was to be completed within that week. Mow, edge, and clip the yard, clean the pool, clean the pool filter, sweep and wash down the sidewalks were routine weekly items on the list. Our bedrooms were expected to be kept up, and Mom

helped on anything we left on the bedroom floor like clothing. This just seems the normal way of life. When Dad would work around the house, we would have to be there with him. Because I was the youngest and as time went by at some point it seems I was the last one working with him on little house repairs. I miss those times and would give everything to be there one more time. When my father passed there was an old tool box with the name Villareal that my older brother Chris claimed as that was a special memory for him.

I remember in our teens it seemed that my brother Bob and I were the ones assigned chores, as most of the others were growing in age and not around as much. My sister Katy was probably assigned most of the indoor chores at that time, but my memory remembers more of my responsibilities. What I do remember is the stupid fights my brother Bob and I would have on who was going to mow and who was going to edge. Our yard was not that big at the time so even now it seems so silly. There is a song by one of my favorite 70's band, America, that sings, "How about a cheer for the humor in my brother. That would brighten up the darkest nights. Just another sign of love whenever we would fight." When I play that song, even the memories of the fights we had are good memories. The song was so true, as it was just another sign of love whenever we would fight. But he was always there to protect and defend me when we grew up. Thanks Bob.

Soon, as teens, we each had different jobs and had our own vehicles and we were always on the run. School, homework, work, maybe a girlfriend and a date, or just hanging out with friends made our lives full and busy. However, the chores, duties and responsibilities, and the list on the chalkboard were still there and needed to be done. Mom kept on top of the list. I believe she did this out of respect for our father. Mom would see me come home, but always in a rush and she would remind me, "Marcos, you still need to clean the pool."

"I know, Mom, but I have to meet my friends at Farrell's. I will do it tomorrow," I said with reassurance.

The next day would be a similar routine, I would pull up in my Chevy Nova, run in and Mom was ready. "Marcos you still need to clean the pool," she reminded me.

"I know, Mom, I will get it done before the weekend. I promise. I will have more time tomorrow," I responded.

Soon this became a pattern, and on some occasions I did not get the work done and at those times I had to face my father. I never liked those consequences. But in reality my mom had warned me several times, as she knew I would face the consequences of Dad. Sometimes the consequences was just having to work with him all day Saturday, and my dad somehow always had a long list of hard chores. Giving up a Saturday meant everything as all my friends were doing things. But I only had myself to blame. However, the next week the pattern would continue. Mom did not like bad habits, and she knew that bad habits would affect my character, and become harder to address if they continued. So one day it was the same routine. I drive up, run in, and Mom was ready. "Marcos, you need to mow the yard," she said with authority.

"I'll get it tomorrow, Mom, I have to run to meet my friends," I stated while running up the stairs to grab something from my room.

Mom was ready. She was waiting at the bottom of the stairs in a position to block me from leaving. I stopped, I probably gave her a smirk, as young teens do, and I stated, "Mom, I have to go. I will get it tomorrow, I promise."

Mom would have none of it. She stood in my way, and in no way would I try to move her. She knew I had that much respect. I hope all children do. "Marcos, sit down," as she gestured to the kitchen table. I walked over to the table, let out a sigh and sat down.

"What?" I asked, and probably showed some emotion, or attempted to.

"Marcos, calm down," she said, as she would have none of my attitude. "You are starting to put things off too much, and it is becoming a bad habit. You need to stop putting things off and just plan better and get them done."

I attempted to reply and give my reasoning, as if it really would make a difference. "Mom, I just have so many things to do now, and I…"

Mom stopped me with a wave of her hand, as she knew that was the magic sign to catch my attention. "Marcos, if you did as much today, as you plan to do tomorrow you would accomplish a lot," she stated.

I stared at her. I wanted to speak, but I knew there was a lesson in the message. Mom could always catch my attention when she truly had a message.

"Marcos, I know you only think its small things and that it is no big deal for you to put things off. It is not about what needs to be done mijo, it's about the bad habit of putting things off. What happens next is you will put off important things, and they therefore become less important. Soon you become less productive. Less productive people do not succeed in life like productive people. I want you to be productive and successful. So whatever you have planned you have to plan your chores in with your other items that you want or need to do. You will be amazed at how much you can get done. Understand?" she asked.

I shook my head yes, and I went to the garage, started the lawn mower and mowed the yard. Funny because mowing the yard probably took all of 20-minues time. I washed up, changed my shirt, and went and met my friends. Another funny thing is that my friends said nothing about me being a little late. It wasn't as if there was something that I was going to miss by missing 20 minutes. I attempted each day to plan better. Many times I simply told my friends that I would arrive a little later. As I accomplished my chores during the week I had my weekends free. Sometimes Dad would ask me for help on the weekend, which I always made time for. But I could see that even he saw the change in me and he appreciated that I showed responsibility and accomplished my tasks in a timely manner.

I knew there would be other times my mother would remind me that, if I did as much today as I plan to do tomorrow, I would accomplish a lot. Mom would recognize bad habits and coach me through them.

That is what strong leaders do. But they also teach how to form the good habits to replace the bad habits. Forming good habits will then make you more effective. The good habit of planning and accomplishing as much today instead of putting it off tomorrow has made me more productive. Habits are formed both good and bad by effort. Leaders understand that they can play a role in building good habits and coaching those they lead away from the bad habits.

In business and as a leader it is important to recognize bad habits. This is why a roadmap to success is important to provide as well as for us to explain why the roadmap is successful. Today I witness too many leaders just saying, "Do it this way," with no education on why that way is successful. In addition, a leader must recognize bad habits that will make someone less effective and confront the situation. Because a leaders mandate and creed is to build other leaders, then that leader owes it to those they are leading to be open with the situation, address the concern, coach on why it will be detrimental to success, and build the better habit for success. It is the passion of a leader to want others to lead, drive success, and pay it forward. That is what keeps leadership alive. Leaders are built one leader at a time, one habit and one lesson at a time.

D) IT'S NOT ABOUT YOU

As a teenager, most your focus is on the moment at hand. I believe it is natural around the teen years to be a little self-centered. Waking up each day I am certain that my thoughts were about what I had planned, who I was going to see, or what I was going to do. I know I did not wake up worrying about others. After all, I was not even aware of others to worry about. So I would wake up and make my way through the day and made decisions based upon how it would affect me. This seemed pretty reasonable, and probably still not uncommon among teens.

Morning would come, I would wake up and get ready for school. I would give a ride to many friends that lived on our street. I had a normal

routine and a specific time that I wanted to leave. Most of the time that worked well, but naturally sometimes a friend would run late. My rule was simple, be there on time or find another way. I would simply leave and not worry about if or how they made it to school. Later that day I may see them at school, and if they expressed frustration I simply replied that they needed to be on time. The conversation was pretty one sided.

It was during this time that I met a kid in P.E., which was my daily physical education class. We were playing basketball and we were on the same team. We played well together and our team won. I introduced myself, and he said his name was John. He was a nice young man, as that would be how my mother would describe him. The next day, John and I made sure we were on the same team again. We once again played off each other well, and won the game. We became common teammates and we won many games.

John would approach me during breaks between classes, or lunch, and we would have brief conversations, but mostly while passing. I think I always seemed busy. But we would sync up in P.E. again, and we would excel as the Mark and John team. It became pretty routine and I enjoyed playing on the same team as John. Each day, I would expect the same routine. At times, John would encourage me to go out for the school basketball team, as John had made the team and he believed my skills were equal to his. My ego probably thought my skills were better, but anyway I just did not have time for the school team. I believed John really just wanted to be my friend, and I am not saying that I was unfriendly, I just never took the extra time to build a friendship.

It was just a week or so that John did not come to school. Because I was not too close to John, I was unaware of any circumstance. Then I heard the news. John passed away suddenly. Apparently he had a brain hemorrhage and died. As stated, I was unaware of what may have happened that caused this, and I never heard the details. I was just surprised, and yes shaken that someone I knew, someone my age, passed away. It was probably one of my first reality checks of life, that life isn't always fair. I only knew that life was not fair to John and to his family.

I went to John's services with friends and acquaintances. I was touched to hear the stories of John that others had to share. There were stories of John's accomplishments. Stories of how John helped others. Stories of his family, and what John meant to them. I would see other friends and acquaintances from school tell funny stories about fun times they had with John. I remember the feeling of sadness that I had not allowed myself to know John better. In a small way I was angry at myself for always being too busy for John, and I knew we would have been better friends. John is someone my mother would have welcomed into my life.

Later that night I went home in a solemn mood. I sat in the kitchen away from the living room where the others were watching television. I guess I just wanted to be alone. My mother noticed my countenance, which she knew was not my norm. She knew I went somewhere that evening, but really did not know the story or that an acquaintance had passed. She came to the kitchen, because her son was more important than a television show. She sat down and asked, "What's wrong mijo, you seem so quiet?"

I really had no response. In some ways I did not know what was wrong. I just knew something was not right. Something just was not right with the world at that moment, and it caught my attention.

"Marcos, is something bothering you? I can tell when you are acting this way that something is wrong. What is it? Where did you go tonight?" she asked.

"I went to a service, Mom. A service for someone that died that I went to school with," I explained.

"Who mijo? That is terrible! Was he a close friend? What happened?" she questioned.

"He was someone I knew, Mom, but not too well. We played basketball together," I replied.

"His poor parents. Are they okay? Do they need anything?" she asked. My mother was always thoughtful of others. She was the epitome of unselfishness. I loved this trait of my mother.

I sat quiet for a moment, and then I explained to my mother what was really bothering me. I told her the story on how John seemed to want to build a friendship and on how I was just too busy for him. I talked about the service and how others spoke about him. I then spoke of my shame that I did not get to know him better. I truly wished I could have the opportunity over, to become better friends with John. I am sure I would have treasured that friendship today. To have had the moments to have known him in friendship.

Mom was great. Mothers have such a loving touch of grace, when they see their children saddened. Mom also recognized a teaching moment. She recognized that I was already teaching myself as I realized I missed an opportunity and took life for granted. She also realized I humbled myself some, which is what she would also try to teach me.

"Marcos, I know you are sad, and that sadness is for several reasons. One, you are sad that John passed, I know that. But two, you are sad that you did not get the opportunity to know John better. Mijo, it is easy to take life for granted, especially when you are young." She held my head against her body. Such a loving moment. She then gave the lesson. "Mijo, perhaps you need to learn an important lesson. It is not about you," she stated.

I was confused. Was she saying the lesson was not about me? So I asked her, "What do you mean about that, it is not about me?"

"What I mean is this, you need to quit being so self-centered about yourself and look at life from a new perspective. Look at life with the perspective that life is not about you, it is about the others in your life. It is about your family, your friends, and who else God puts in your way. If you learn life from this perspective and focus on others your life will become more enriched by the others doing the same for you. When you help others, befriend others, teach others, you will learn more in life and grow faster in whatever you're doing than when you focus on just yourself," she stated so eloquently.

I still sat quiet, but I heard every word of her message. The next day when leaving for school, one of the individuals that would normally ride

with us was not there. When I drove away, I went a different direction and the others in the car noticed and questioned what I was doing.

"I thought we would go drive by Skippers house to see if he is just running late," I said.

They said nothing. They were just surprised. Then as we pulled up to Skippers house I honked and he came out surprised as well as he knew he was late and was already looking at another way to get to school. Skipper jumped in the car and we drove to school. Nothing else needed to be said, because it was not about me.

This lesson was not only a lesson for life, but also for business and leading others. This is where, as a leader, when I focused on others success mine came naturally, mine blossomed. From focusing on others my life has become more fulfilling as others grew into leaders and then mentored others. As we define future leaders we owe it to them to teach them this lesson early in their development. As we mentor them they will see by our example how we spend our energy on them and on others. We then celebrate their success and give them the credit. Why, because it is not about you.

E) YOU CANNOT CONVINCE THE CONVINCED

This statement may sound confusing. You cannot convince the convinced? What does that mean?

So there I was, frustrated about a situation where I was trying to give close friends of mine advice and even warnings of a situation about their possible decision and their opinion could not be swayed. I even pointed out past examples of what they were planning and that others had attempted similar plans before and what the results and consequences of those past attempts had been. My friends liked to take trips to remote places in the mountains or the desert, but they would sometimes go ill prepared and even worse, they would lack to inform others where they were going and what they were doing. I had expressed many times the possible dangers in this type of thinking, but they actually thought that

added to the adventure. Somehow being foolish and risky was the cool part of their plans, and safety was least in their belief system. So I was listening in on the different ideas of what they were planning with the discussion about the mountainous area and about what supplies they needed. I spoke up with some questions and some cautions.

"Are you sure that you are taking enough supplies?" I asked.

"That will be all we need for the three days," my friend responded.

"Yeah, but why not take a little more, just to be safe? What if something happens? If nothing happens you will just have extra," I stated in a rational tone of voice.

"Relax," another friend said while laughing. "You are such a worry wart. You are not going anyway so why do you care?"

"I am just giving you my opinion, as I believe it is better to be safe than sorry," I replied.

Laughter erupted amongst my friends. They thought my worry or my response was funny. Maybe they thought I was less cool because I expressed a concern. I am not sure what their mindset was. I was just expressing legitimate questions and concerns to their planning, or what I considered a lack of planning. At this moment I excused myself and walked away. I do remember that my question came from what I had learned from others who did similar trips, but they would take extra supplies in case unknown circumstances would arise. They would let family and friends know where they were going, their path and expected timeline. All this seemed very reasonable for the rare occurrence that something should happen so that others would have an indication on where to start looking, etc.

It is important to realize, this is not to say we should not attempt what others may have tried and failed at. Technology and discoveries would not have advanced if others had not had the courage to do so. But those that overcame where others have failed understood that there was a lesson in the previous failures. Learning from that lesson was an important part of their planning, caution, and vision. They would

understand what the future warning signs might be and include that in their planning.

So there I was frustrated, and my mother saw this. I walked her through my frustration and the situation with my friends. She saw that I was more upset that they would not give me the benefit of their time and listen to my concerns. I had thought that through our association, friendship, and honest regard for their well-being, that they would at least give me that benefit. They did not.

My mother paused, looked at me and said, "Mijo, you cannot convince the convinced." She explained that in life I will encounter situations where people may not give the benefit of at least listening, or they may not even want to hear what I had to say. Sometimes people get enamored with the idea instead of the plan. She said all I could do is give my effort by at least offering up my opinion and concerns.

My mother also stated that lessons will also teach me that my opinion may be vastly different, and although I may believe my opinion to be correct, the other opinions and ideas may still succeed. Just because it is my opinion does not mean that it is correct. In both experiences I need to be humble enough to learn. The fact that I gave my effort is all I could do. Obviously my opinion in these matters was more out of concern as I did not want my friends to encounter hardships or harm.

The important part of the lesson from my mother that she wanted to make me understand and learn from was for me to understand the reason that I was frustrated. I was frustrated that I tried to give my opinion and that I believed that I gave good examples and made a good argument with facts and data. My frustration, however, was that I believed my friends did not at least take a moment and listen to the information that might have assisted them as they decided to move forward.

She made me understand that I was more frustrated because I believed that I was not listened to, or that my data or facts were not considered. I believed I had a good argument and that my friends decided to move forward anyway. She counseled me that we can sometimes can only be advisors or influencers and none of us truly wants to say, "I told you so."

The biggest lesson I learned, and that we need to learn as leaders, is to not let the frustration irritate us to the point that it continues to affect us. Other great leaders teach that sometimes people have their minds made up and all we can do is to offer our advice. Sometimes others need to learn from making their decisions and working through the results. I value this lesson from my mother. Yes, Mom, I know, you cannot convince the convinced. But as you taught me, at least I gave my opinion and concerns. I hope we all learn.

It was not long after that I would see this play out in business. On many occasions I would give an opinion on decisions or direction that my organization was planning to execute, and my opinions played no role in the decision. Sometimes the other direction succeeded, as my mother stated that just because I have an opinion does not make it the right one, or the only right one, or that other choices might still have success. The key was just making sure that you give your counsel and do not let the final decision frustrate you, or that other mindsets were not changed frustrate you. You cannot convince the convinced.

As leaders we must teach how to offer our opinion and advice professionally. How to make your arguments and responses to other opinions, and be satisfied that you are at least heard. The next phase is to work to execute the direction chosen, wholeheartedly. Furthermore if the direction chosen stumbles, be a team player and work to correct the direction for the good of the organization. If at some point the direction crosses your core set of values, then at that point you may reassess if you are with the right organization. I have a good friend who was once my manager and leader, and I know that this leader will not sacrifice on ethics. If ethics are ever in question, this leader will not hesitate to bring the issue forward, and this leader will decide the organization is not for him if he realizes the organization chooses to sacrifice on ethics. To him the choice is simple and I admire that about him.

As leaders we mentor our future leaders through the exact same core value system. Choose your values and principles, and question if you ever see them sacrificed. Offer your opinions, advice and feedback, and

be committed to the decisions made moving forward. Then understand, that you cannot convince the convinced.

On a final note, those friends back in High School went on a trip and their car broke down on a deserted road. They had slim supplies, a lack of money and no one knew where they were to track them down. After some worry, family and friends finally heard they were okay as they managed to hike their way to a ranger station where they were able to contact family. They admitted they felt foolish and had learned a valuable lesson. I was happy to hear that they were safe, and I never said "I told you so." They actually became great planners and safety conscious from that moment forward and one of them works for the forestry service today. Perhaps it was a lesson they had to learn on their own as I now know that you cannot convince the convinced.

F) GIVE A BLESSING, GET A BLESSING

Mom was a woman of faith. She believed in the biblical teachings. I believe she chose simple things in life and trusted blessings would come her way. I believe she had a blessed life. She loved all of us so very much and I know each of us never questioned her unconditional love. She literally sacrificed her whole life for us as some might see it, but to her it was a gift she wanted to give. It has taken me my whole life to realize and appreciate everything that she was. I truly hope that I did not show at any point I took it for granted. I think maybe we just do not think of it this way as we are growing up. We just live in the moment.

Mom wanted us to always be respectful. Certainly respectful to our father and respectful to her. But she taught us to respect each other and people in general. She appreciated when we opened doors for others, and when we gave up the best seats wherever we were at to others. To me, this is biblical teachings and I believed it pleased our mother when she saw us show others respect. After all, what could anyone say badly about ones children when they could witness that they demonstrated respect for others. I believe Mom believed our ultimate respect to her and our father was to show we were respectful to others.

I remember around the holidays that in school we would decorate the classroom and learn about Thanksgiving, and about the Pilgrims and about Plymouth Rock and the original Thanksgiving Meal. We dressed like pilgrims and Indians and acted out school plays about the giving and sharing of two new societies meeting and deciding they could live together. Around Christmas we would celebrate in school and even exchange gifts. Things have certainly changed in our society since those times. I remember the feeling of excitement just to see what I was going to get.

It was in my teen years that I started to change in how I felt around the holidays. I am not sure of the exact instance, but I had a good friend who lived on the same street that focused on giving and doing for others. At first I wasn't sure what he was doing or why, but I did start to help him when I had spare time. To me, it first appeared that what he was doing was being mandated by his parents and maybe by tradition. But he showed he enjoyed it, even looked forward to it. His joy was infectious and I looked forward to when we did things around the holidays that gave or helped others.

Mom saw this and it caught her interest and it obviously pleased her. Mom always taught us to have concern for others and when she realized that I was assisting my friend to help others she did that natural thing any good leader would do and she taught me a lesson that was important to her. She asked, "Mijo, are you helping Skipper today?"

"Yes, Mom, we are doing a car wash to raise money," I said with excitement.

"That is good mijo, I am so proud of you," she said.

"Thanks, Mom, can I take some of the buckets from the garage?" I asked.

"Sure, just remember to bring them back," she replied. She then called me over to her and she hugged me.

Great leaders enjoy, and they jump at the chance, when they catch one of their individuals they are leading doing something right. Years later I would actually read that advice in a management book, but it

is a natural growing process that if someone is doing something right, acknowledge it, reward it, and they will grow from that moment. Mom's hug was the reward. The fact that she said she was proud of me was extra, but was awesome as well. But Mom took the lesson a step farther. She lifted my head with her hand when hugging me and said, "Mijo, by giving a blessing you will receive a blessing. This is God's way. He rewards those that give openly and cheerfully."

I don't believe I said anything. Maybe I seemed non responsive, but Mom wanted me to understand this important lesson. "Mijo, listen. This is important to me. I want you to understand what I am explaining. I truly believe that if we bless others, God will bless us. It warms my heart that you are helping your friend do for others. Good things will come from that."

"Thanks, Mom," I said. "I certainly hope so."

She pinched my left arm, as Mom would do to get my attention. "Mijo, don't hope, don't worry, and don't do things because you want something in return. Do things because you are capable and available to be there for others. Let the joy of helping others be your reward. Then when God blesses you with more, tell the Lord thanks. Those you have helped will be grateful and in time they will have the same opportunity to help others, you'll see."

Her lesson made sense. I certainly saw people treat me differently at the time. By helping others I could see others treat me with respect that I am not sure I saw before. Up and until this very day I enjoy a smile when I open the door for someone or let someone go ahead of me in the grocery line, and those are just little things. I wrote earlier about some good friends whose two boys we send gifts to and encourage their dreams. As Mom taught me, my reward is the joy that it brings to my heart and that joy excites me. But the bigger lesson I have seen over the years is I have seen blessings come my way. Some may call this karma, while others may label it coincidence. To me it is the very principle of give a blessing, get a blessing.

I believe the core of leadership and leaders is the give a blessing and get a blessing. Leaders look to give, without the expectation of

receiving a blessing but leaders also look to give because their very nature understands that the giving of themselves by leading, teaching and mentoring others is what develops individuals. Just as individuals may have an innate hunger to be led, a leader has an innate hunger to teach and develop future leaders. The blessing leaders receive is individuals that grow, develop and become successful that then lead others who continue the process. I enjoy teaching leadership and seeing others succeed. That truly is receiving my blessing.

G) YOUR EGO IS NOT YOUR AMIGO

Funny, but we all have a desire to want to look good, get recognition and do well. That is a healthy attitude in life. But we all need to recognize the balance of wanting all the credit to giving all the credit. In leadership, great leaders like to see the success of others, especially those that they took an initiative and interest in seeing them develop. This is what I call a good sense of pride of witnessing how those you mentored are leaders themselves. This gives great leaders their sense of purpose. One of the most important things I learned as developing as a leader, is your ego is not your amigo. In fact, the best leaders check their ego at the door.

I remember back in Jr. High and High School how I enjoyed playing sports almost every day. We would play after school many times on the field just over my backyard fence as there was an elementary school located there. I remember I was always competitive and like any young man or boy I always wanted to win. If I did not win I would work on my skills some more and go out next time and try to win. Winning felt good and at that age, being a winner gave one an ego. I had an ego.

I remember in Jr. High and my High School years that I loved playing tackle football with my friends. When we would play I would always choose myself to be quarterback. We would play and my quarterback skills were okay as I had a strong arm that was accurate and the ball would come out with a spiral. I can still remember many games and special moments of throwing a deep pass that the receiver caught in

stride that seemed perfectly placed over his shoulder. How I loved and how I lived for those moments. It is those moments and winning enough times that keep you playing.

As I grew into my High School years we would still play after school and in P.E. class we would play flag football and I would still choose myself as the quarterback. However, something changed between the Jr. High School years and High School years that had an effect on me. That change was the size of the football as High School footballs were the same size as utilized in college so they were bigger. The bigger balls made it a little more difficult to throw as it seems all of my brothers and I had hands like our Mom had, which were smaller, and even though mine are the largest of the boys it presented this challenge.

So I remember one game after school we were playing and I was quarterbacking and one of my friends asked, "Why do you always get to be quarterback?"

I answered swiftly and decisively of course, "because!" I am sure that settled the matter and it seemed to as we went back to playing. Ironically, and as fate would have it, the next play that player ran down the middle of the field and I hit him in stride right over his shoulder that he then ran for a touchdown. Argument is over. That is why I get to be quarterback. However, as fate would have it, the next time we had the ball another player was wide open and I reared back to throw the ball and I lost my grip and out of my hands came a wobbly duck, way off target. It was a sad moment. Funny but no one shouted back. I heard that player say something like, "dang it" but we went right on playing.

Later at home my routine would be to drink something cold and make me some food. I was sitting at the kitchen table when my mother walked in and she asked, "How was your football game?" Mom just always wanted to show that she took an interest in what we were doing. That was her leadership love.

"Okay I guess. We won," I responded.

"That's good mijo. Just be careful and don't get hurt," she stated. She then mentioned how she saw some of the game when she was

upstairs and caught a glimpse of us playing through a bedroom window. She mentioned that she saw the ill-fated pass and thought I had hurt my arm or something.

"No, I did not hurt my arm. I just lost my grip on the football. Why do we have to have the Torres hand?" I asked. You see, my mother's maiden name was Torres and we always blamed the trait of smaller hands on that side of the family.

"Mijo, your ego is not your amigo," Mom stated. She had a way of saying quotes or statements out of the blue, but they were revealing. I sat quietly. Mom then explained that because sometimes I would lose my grip that I should let other players play quarterback and I certainly had the skills to play other positions. She said my ego was getting in the way and that I needed to recognize my strengths and weaknesses and when I would learn this I would learn to play to my strengths.

The next time we played I allowed someone else to be quarterback and I played receiver. Funny, but I was a very good receiver as I had strong fundamentals of catching the ball and pulling it into my body quickly, so I made good catches. We played and we won the game and I contributed with my play as receiver.

Over time I did learn to throw the larger footballs through an unconventional style by gripping the opposite side of the laces. I worked on gaining that grip quickly and threw the ball accurately. Years later in my mid-twenties and while in the shoe business we would challenge other shoe stores to a tackle football game. When we played I would play quarterback and I remember during one game I was throwing well and we were winning. Then of course one play comes along where one of our players are wide open and I release the football and out comes a duck. Wobble, wobble and the balls goes nowhere. What I remember most is my reaction, I just burst out in laughter. By learning that my ego was not my amigo I even learned to laugh at myself. That is probably the best part of the lesson.

Since that time I have had the benefit of having strong mentors in my life starting from my parents, to teachers, pastors, and those I have

had in business. One such mentor also taught me to recognize your strengths and be honest about your weaknesses. He believed that there are ways to work to develop areas that are considered your weaknesses. In addition there is also value in determining if the effort in trying to change that weakness outweighs what can be achieved by spending that effort in maximizing your strength. This is truly something to measure and discern.

Anyway, this mentor openly and honestly stated that why he hired me to run the business is because he knew that he lacked the people skills to do it effectively and that I had that ability. I found this interesting because he openly admitted a weakness in his abilities. But in addition, he not only admitted the weakness he decided it was not worth the effort for him to try to develop around this area or that he would struggle to develop in this area. He recognized that a smarter decision was to focus on his strength and find a better solution to work around his weakness. Watching this in action and how it played out was a valuable lesson.

This person, one of my valuable mentors in life and business, also taught me and expanded on the lesson that your ego is not your amigo. What this truly meant was just to be honest with yourself and others about strengths, weaknesses, and the balance needed for both. Our partnership in my employment with him was a tremendous success. This person, my mentor, was a great business planner and he was greatly thought of as a leader as well. He recognized that to be most effective in our business that he needed another leader to compliment his areas of weakness so therefore all areas needed for success would be covered. This was a great lesson for me to be a part of.

As I have moved forward to be associated with other teams, I have witnessed where other great leaders have not allowed their ego to get in the way. However, we all have probably even witnessed the opposite in leaders where they struggled with recognizing a weakness and it affected others. I believe the best climate is one that builds a culture where it is not about ego but about execution. That is truly a culture that is exciting to be a part of. One of the best comments I have ever heard from a

leader is when that leader stated, "If I am in the way, you need to let me know. I do not want to be that guy." That is a leader that is secure in his own skin. That leader knows that his ego is not his amigo.

H) LEAD, FOLLOW, OR GET OUT OF THE WAY

In my High School years I worked in the fast food industry. In my day that was the type of work available for our age group and I had a knack to do the work well. In fact, even as a teenager I excelled in this work environment and took on beginning management roles like being a shift supervisor. I quickly grasped the responsibilities but also had an eye for recommending improvements in processes and operational efficiencies. This caught the eye of upper management and allowed me to grow, learn and develop. What it taught me the most was that I had good opinions that mattered, even as a teenager.

It was about this time that I was with my second employer which was a fish and chip fast food restaurant in California. Once again I excelled and became a Shift Supervisor, of which I enjoyed the responsibility. The business was new to the California area and we were the second store to open and we seemed to be catching on. With the potential growth of more stores I saw an opportunity to at least work hard, learn, and possibly grow with the business. So I made sure that I shared my ideas, took initiative and let ownership and management know that I had an interest in growing and advancing. They seemed to appreciate me and I was treated like a valued employee.

As time went by there were others who also were Shift Supervisors who wanted to advance. One Shift Supervisor was promoted to Assistant Manager and was a couple of years older so they were grooming this person to be a manager. This was a person who worked hard and had good character. They did, however, when promoted seem to struggle with self-confidence or what one might call an inferiority complex. At times this person might lash out when challenged or another opinion was given and it was starting to effect the environment of the workplace.

Prior to their promotion the environment allowed us to share ideas and opinions, debate between them, and decide what was best for the business. This person was part of that prior process but they seemed to have changed and they became protective of their own ideas and own ways. In many ways this can be a growing stage of management that their manager should be observing and coaching them through this stage. Many first time managers will find themselves in what is called a firefighting stage. It is a stage they will have to develop through. Great leaders will recognize young managers in this stage and coach them through it. The manager above this Assistant Manager was busy assisting opening up a new location so this situation was lingering longer than it normally should.

It was important to me to still support this Assistant Manager and help them grow in any way possible. I would encourage the others to be respectful and assured them that it was just a transition phase. I believe that I would even attempt to be the go between in an effort to ease any tension and I would also try to offer advice or insight to the Assistant Manager. Soon it became apparent that the situation was not improving. The Assistant Manager was making the situation unpleasant and was managing in a way that stifled innovation, initiative, and a fun environment. Members of the team spoke about just quitting and finding another job. I could see how this even effected the quality of our work and our product. This is an important aspect of leadership, to understand the environment this can create and how it then effects how the team will produce in efficiency, productivity and quality.

Soon I noticed I was becoming apprehensive in speaking up, voicing opinions, and even leading as I should. I would hesitate to correct and coach when I encountered these situations because at times I did the Assistant Manager would intercede and contradict my coaching, even though my coaching was in line with restaurant policy. I soon began contemplating leaving and finding work elsewhere. I do believe it is important that if you are not in a job that you enjoy and you do not look forward to going to work, then this should be an honest consideration.

However, we had an all employee meeting scheduled in a week and I was wondering if I should attend in the hopes that maybe an announcement of new changes might be discussed, or I contemplated if I should voice these concerns at that meeting.

One day I was sitting in the kitchen at home looking at the want ads in the newspaper. My mother came into the kitchen and she noticed that I was looking at the employment section.

"Mijo, did you leave your place of employment?" she asked.

"No, Mom, but I am thinking about it," I replied.

"Did something change there? I thought you liked that job?" she queried.

"I did, but with the recent changes it is just no fun anymore," I answered.

"Is there nothing you can do that can impact the changes and improve the situation?" she asked.

"I have tried, but I get shut down. Our new Assistant Manager is just shutting everyone down. I am not the only one looking at leaving," I responded.

At that moment my mother sat down at the table with me. We spoke about the subject more. She was always easy to talk to and willing to listen. I explained that when the new Assistant Manager was a Shift Supervisor equal to me that they were a good team player, but that the new role has changed them. She asked about the coaching the Assistant Manager was receiving from their manager and I explained that there was very little because that manager was assisting another store opening. I explained I did not want the Assistant Manager to fail and I actually believed they could be a good manager because they showed the qualities to earn the promotion. I even explained that I tried a one on one conversation with this person to express the concerns and I was shut down by the person and this is when things appeared to get gradually worse from that point. I then told my mother about the upcoming all employee meeting and my thoughts of voicing concerns at the meeting. This is where she gave me her advice.

"Mijo, I believe you tried handing this situation in the right way. In all things be professional even if others are not. If you are professional they can never say you were unprofessional or say anything about your character. But I do believe that it is important that you voice your concerns to your employer. I believe that you owe that to them and to your Assistant Manager who can still succeed if corrected. If after you voice your concerns and things do not change, then you can leave with a clear conscious," she stated with wisdom.

I listened, and may have seemed a little quiet. Then I spoke, "I am not sure, Mom. I…."

"Marcos, you need to lead, follow, or get out of the way. You are allowing yourself to do none of these. I would rather see you lead and speak up. If you decide to follow, then it's time to shut up. But I rather see you choose to follow when it is a leader you desire to follow that teaches and mentors you so you develop more. In this situation, after you attempt to show leadership and speak up and you do not witness the changes needed for improvement then get out of the way and find another place to work. I agree that if you stay you are just in the way because you will find yourself in discontent," she stated.

Wow! My Mom had passion. I believe she passed that passion on to me. I am sure my brothers and sisters share my mother's passion in the lessons that she passed on to them. Her advice was what we call spot on, which means it is accurate. I need to lead, follow or get out of the way. In a few days our all employee meeting was held. When it was time to speak up and voice concerns I was prepared and spoke up professionally and with examples. For a moment it seemed it might escalate and become a combative conversation, but I did not respond combatively. I expressed that my concern was as much for my Assistant Managers success as the restaurant and employees as well. Soon others added their feedback and it went into a meaningful conversation. The main manager witnessed that we cared for the organization and for our Assistant Managers success. He acknowledged that what was expressed was duly noted and that he would create a plan around it.

As the next few weeks went by the environment improved and the place became that fun workplace to work in again. The Assistant Manager was provided some leadership training and coaching and really started to show their trust in others. This allowed the Assistant Manager to build a strong team that rallied around them and the restaurant flourished. That Assistant Manager was promoted to manage a new location and we were all excited for them and in a way sorry that we would see them go. That Assistant Manager thanked me for being a team leader and for the moment that I spoke up. Humility as a leader is truly a strength and not a weakness. This Assistant Manager developed into a leader. Mother's advice was great advice as I realized that not only does lead, follow or get out of the way impact our own growth but can also impact others growth as well.

As the years went by, Mom reminded me a few times of Lead, Follow or Get Out of the Way. Great leaders repeat themselves constantly because they know that the message is important. Human nature also teaches us that important lessons teach us their importance and then allows us to teach and coach others. As leaders we must mentor future leaders that they need to define when to lead, follow or get out of the way. We want individuals to demonstrate leadership. This can be in their actions, innovation and feedback they provide. When you choose to follow then ensure that it is for the right reasons that match your values and principles. Following and being mentored by an awesome leader is a solid example. But it is important to understand when to get out of the way. If you are impeding progress, or find yourself discontent of the direction then do a self-evaluation as it may be time to get out of the way.

Lead, follow or get out of the way. Sounds so simple, but is it? I have personally been challenged in this area at times and have witnessed others in their challenge as well. The boundaries come when your values are stretched within the environment and if they are outside your values system you then become part of it. However, after all, we all need employment and the security of a paycheck. The decision comes when

you determine what area you find yourself in. This is why lead, follow or get out of the way is so tied in with values are what you live by and principles are what you stand on. If you find yourself not standing on your principles then it is time to get out of the way.

Leadership Lessons From Mom

CAPTURED MEMORIES & LOVING PICTURES OF MOM

"The Best Leadership Coach Who Chose To Be A Housewife"

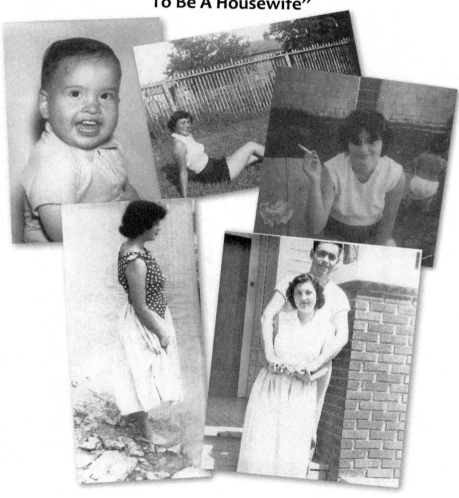

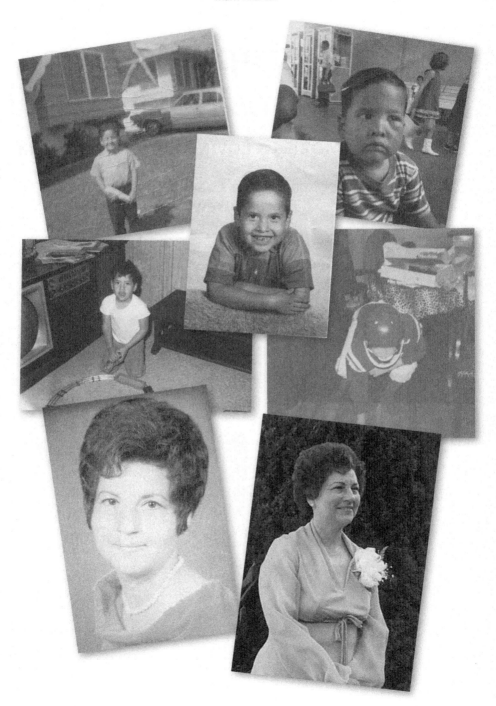

CHAPTER 4

Early Adult Years – Reflection of Your Past

A) WALKING ON EGGSHELLS

My father was a stern man as he was a drill sergeant in the army before I was born. My father raised us with strong work ethics and he demonstrated courage all through his life. However, at times, because of his outer strengths and personality, he was difficult to stand up to. He was always larger than life to us and like any father, would not hesitate to defend his family. But it was more than that, as my friends that I had while growing up in our neighborhood looked up to him as well. He defended our group when a neighbor was harassing several of us kids, and everyone saw my father as a dominant man. I think he enjoyed that.

While growing up I was not combative as a child, not that I am I saying that we need to be. But my father's presence and demeanor showed him through life how to get his way, attain his goals, and succeed in what he was doing. He knew he had this presence and used it naturally to dominate and push to get his way in life. Because it always worked for him it became a natural part of his personality, whether in his work or home environment. Maybe it was he had to fight for what he gained in life and he worked hard to provide for his family. People

who intimidate, whether intentional or unintentional, sense and learn that their intimidation is a method to achieve their way. Intimidation brings success to them. Intimidation becomes so natural they may not even realize it.

As I aged into a teenager and early adulthood, it was important that I grow as a young man and to develop into a man who would also set goals and succeed. Those goals were goals of business and goals of leadership. At one point I worked in a business with my parents and offered my opinions and feedback on growing the business. Some situations occurred that I felt very strongly about that I believed I really needed to speak up about. But my father's dominance brought hesitation. So there I was allowing myself to always be intimidated by my father. My mother, recognized my hesitancy and knew it not only was not a healthy environment if I allowed it to continue, but that it would alter my growth as a leader if I did not learn to confront the issue. Great leaders know this in those they are leading. My mother knew when I was maturing not only physically, but mentally, and knew this was an opportunity for growth and development.

Mom knew the right situation and the right time to take a moment and teach me one of the most important lessons in life and in business. My mother saw a situation where she knew that it would add value for to me to learn to be heard. She knew that I had to learn to speak up and believe that my opinions had value. Learning to share my opinions and debate them would prepare me to lead and build my confidence. Mom knew that for me to develop and to be respected and appreciated that I had to learn this life's lesson in her mental motherhood leadership book. My mother said, "Marcos Antonio", she spoke my first and middle name in Spanish when I was in trouble or when she really wanted to get my attention. She gained my attention. My mother continued, "The moment you allow yourself to walk on eggshells you will find that there are eggs at every turn."

What? I thought in my mind. It sounded very confusing. But it wasn't. Her lesson was that if I allowed myself to walk on eggshells, and

continued to allow myself to walk on eggshells, it would not get better, but worse. Eggshells would continue to be all around me and I would have to watch where I walk. Her intention was to push me to be a man, as my father would have labelled it. Her intent was for me to develop as a man, and develop as a leader.

So I confronted my father on the situation that was pressing before us. He tried to intimidate, but I stood my ground and voiced my opinion. I showed and demonstrated my courage. My father paused, listened, and hugged me. He said, "This is the moment I had been waiting for." He then allowed us to talk about the subject matter, and he listened intently. As time went by he would seek my advice, opinion, or insight.

From that moment on, our relationship was never the same. It was better. I earned his respect and he gave me his trust. I remember later in life that my father depended on me as I was the one living the closest, but I also know I earned his trust as that is what he communicated. I say this as an honor, not with ego, as it was a privilege to take care of my father later in life. I remember even in his later years that we had a time or two that we had to address issues and we did, as neither of us would allow each other to walk on eggshells. Some issues may have been uncomfortable, but they were important to confront. This lesson from Mom I saw continuously, and still see today, and I realize that life is only a lesson for business. Remember, the moment you allow yourself to walk on eggshells you will find that there are eggs at every turn.

So how does this affect us as we teach, mentor future leaders, or provide leadership? Sometimes this may be confusing, especially for a man of faith like myself, when many of my prayers I leave in the hands of the Lord. But I also know that the Lord wants me to be in an environment that I can benefit from and one that is built on the right values and principles. He desires that for each of us. So at times, I personally, have found myself challenged when I see areas of ethics crossed that are without question not in line with my values and yet we all need to be employed and make a living. In this situation I at least confronted the situation, voiced my concerns to leadership and to

Human Resources so I know I have voiced what I stand for. Then from that point on if the situation continued then I either become complicit in the situation, which really means I become part of it, or I need to stand on my principle and leave the organization. Remember that principles are what you stand on.

This is an important lesson because leadership is leading by example, so others may witness or know that ethics are being sacrificed and they then may associate you as being complicit. That hard part of ethics is the decision to cross that line of ethics, always starts with the smallest situation where you will hear rationalization of why it is okay in this circumstance. But once the code of ethics breaks then it is hard to keep ethics in a box as it will always grow and others will cross the line with their own rationalization. I, as a leader, have witnessed this many times. Ethics are like gossip. When you hear managers gossip about others constantly, eventually you will wonder what they say about you when you are not around. Just as ethics are sacrificed when someone starts to gossip, then the next decision to cross the line of ethics becomes easier and at some point may be something regarding you or your department. It becomes inevitable. So as you encounter and allow yourself to walk on eggshells remember what my Mom taught me, the moment you allow yourself to walk on eggshells you will find eggs at every turn. I would rather trust where I walk.

B) MISERY LOVES COMPANY

I remember being promoted to being the manager of my own location of a fast food restaurant. I was young and ambitious and this was exciting as no one had been promoted at my age at the time to manage a location within this corporation. Maybe I needed to check my ego at the door as I was in for a challenge. The location happened to be in a retirement type town, so the average employee age was much higher than I was used to. So I went forward and believed I could win the employees over, after all, I earned the promotion.

At this early point in my career, and being the new manager, I tried to win over everyone. However, there was a group of three individuals that kind of formed their own group. They were good workers and knew the restaurant well. However, they seemed to question my every decision. I did not mind anyone asking about a decision, since I believed in allowing feedback and opinions, as that adds value. However, these three questioned and then voiced their dissent on almost every decision, or at least it felt that way. What made the situation worse is they would voice it to others and stir the discontent. I tried to win this group of employees over, but they were never satisfied. This caused me to struggle as a manager and as a leader. I believe others were looking for me to lead. Instead, I tried to compromise. Still the group never seemed satisfied.

I allowed myself to walk on eggshells. It is amazing how many times these lessons arise throughout life. This is because life is lived in the valleys, which bring all the challenges forward. I struggled and failed as a manager. I soon found myself unemployed from a place that I could have had so much success. The next manager that replaced me had more experience, quickly defined the bad character of the three individuals, gave them a chance to change, and then removed them from the business. This was a valuable learning experience for me, as I watched this manager come in and lead.

I remember speaking to my mother as I was transitioning to my next role in life. She saw the hurt and disappointment I had from the experience. She also knew that disappointments would come to each of us in life and how we would face them, learn from them, and confront them was an important aspect in helping us become better from the experience. Mom reminded me about life being lived in the valleys, but walked me through my experiences from the view from the mountains. She asked if I liked being a manager, I said yes. She asked if I believed I could still be successful in management and if I learned from this experience. I also replied yes. But then she said, "Mijo, misery loves company. Sometimes you will encounter individuals who are just

miserable and because they are miserable they want you to be miserable. They want everyone to be miserable."

I must have looked confused. As I remember thinking why would someone want to be miserable? So I asked, "Mom, why would someone want to be miserable? That does not make any sense to me."

"Mijo, I don't know why. It is something in their character that makes it a part of them. You will see more people like this. They are not only miserable, they believe everyone else should be miserable around them. This seems to give them pleasure. Ruining your career at that restaurant probably gave them satisfaction. I can only pray for them mijo," she replied.

"So what am I supposed to do when I encounter people like that?" I asked.

"If they are in your social life, separate yourself from them, or you will become like them. If they are in your work environment and are equal to you, do the same, separate yourself from them as you do not want to be identified as part of that group. But if you are their manager, become a leader and do what you told me the next manager did that took over after you," she answered.

"He let them go," I stated.

"Yes, he did. But you mentioned that he identified what they were doing, addressed it with them and gave them a chance to change, and released them when they did not change. Now he showed leadership for all of his employees. He knew that their misery would spread. He knew that misery loves company and keeping them was not beneficial for the team," she stated.

"Boy, I wish I had done that. They were good workers though, which may have swayed me wanting to please them, or get them to like me. I now see that they simply wanted to spread misery, and I allowed that," I replied.

Mom responded, "Mijo, that is what makes it hard. Miserable people just have something in their character that makes them miserable and they believe everyone else should be miserable as well. But they can

still be talented individuals that can be good at what they do. This is why when the other manager identified the situation, he confronted the issue and gave them a chance to change, but when they did not change their quality of their work became a non-issue as they would become more damaging spreading misery. Remember, misery loves company and they simply would have kept spreading it."

Mom's lesson really opened my eyes as this was my first experience in a work environment to truly face this type of situation. I believe that I did come across miserable people in society, but there it was easy to not be associated with them. In a work environment a leader must recognize the issue, address it, coach and see if it can change, and then take action and eliminate the misery. Because misery loves company. We must remember that another danger, that as a leader we face, is having someone with strong talents, yet they are a misery loves company-type of person. The danger is we believe we can manage around the misery part, the complaints and discontent, because the talent part has value. Unfortunately that misery, complaining, and discontent will still spread. Why? Because misery loves company, and they will always look to find it.

As I mentor leaders, I utilize my own experience and tell this story. I am better because it occurred and my mother coached me to learn from it with her excellent leadership. I have encountered several misery loves company situations in different businesses and many have been individuals with strong talents. Then I have witnessed those managers struggle through the situation because they believe the talents of that individual either outweigh the misery effects or that they somehow can contain the situation. I have not witnessed a successful outcome as that manager wears down on energy and the misery will always show itself. Misery truly loves company.

C) IF YOU FIND YOURSELF GOING AROUND IN CIRCLES

Like most sons, I always looked forward to my visits back home. Like most men, I always looked forward to Mom's cooked meals. Oh, the

good ol' home cooking was the best. I long for it today. Mom made homemade tortillas that I could just heat and add butter and be in heaven. Her fried chicken was the best and eating the crumbs at the bottom of the bowl was a treat. The smell of her Spanish rice would make your heart melt.

What I miss most about my mother is our discussions. No matter what age I was, I could always talk to her about challenges. Mom always had time to sit and listen and she had the patience to hear the story behind what was being discussed. I am not sure she intentionally knew that she was teaching me leadership, but in her loving way she believed she was preparing me for living a life that would have challenges and roadblocks.

There I was, a young manager in a business, and I was discussing with my mom some of the challenges I was having. I explained to my mother how I believed the business I was managing could grow and achieve success, but that I was having challenges with implementing plans and actions that the employees could complete and drive to success. Yes, between each bite of her famous fried chicken I would explain the struggles I was encountering with my managers completing tasks or assignments, or keeping pace with the rate in which I wanted things implemented or accomplished. My mom knew just the way to question me to gain insight. She would ask me, "How are you guiding them and what are you providing so that your managers understand your guidance?"

Great question, Mom! My answer was vague. It would be something I would have to think about more in order to answer more thoroughly. This might have been evidence that I was maybe rushing into situations if I did not immediately know the answer. That was when my mother stated, "If you find yourself going in circles, you probably cut too many corners."

Wow, what does that mean? My mom explained that if I am not creating a complete plan with my managers, the managers and other personnel would then lack direction. This compounded with the lack

of a complete plan would cause disarray because I would then pressure them to be further along when I did not provide the plan or the steps for them to be at that point. I was causing chaos with my team. I asked my mom, "How would I implement that process now? I think that would be embarrassing to admit to my managers that I am the problem."

My mom was always quick to point out that humility is a strength, not a weakness. She stated that she believes my managers and employees would appreciate the honesty and would even want to participate in the planning. She was always correct with this belief. She repeated, "If you find yourself going in circles you probably cut too many corners. You need to understand this mijo because it is easy to correct. It takes humility to be honest with your team that you may be the cause, but they will appreciate your honesty as a leader and be open to assisting you in working through the solution.

So I trusted my mother's advice and called a meeting with my team. I addressed the situation factually on things we were not completing and how this was affecting our performance. I then stated that I did a self-evaluation on whether I was providing the right guidance and if we were planning properly. The response was open and positive. Others had great feedback and ideas that enabled us to build a newer plan incorporating many of the same factors, but we built in better accountability, milestones and timelines. The team rallied around my leadership and we became one of the best performing offices in a short time. Cutting corners did not save time or achieve results quicker, cutting corners caused confusion and apprehension. Cutting corners had us to going around in circles.

This one simple message has taught me so much about leadership and planning. We owe it to those we lead to plan properly without taking shortcuts. Proper planning will allow us to still move at a fast pace, but will allow us to execute to the fullest. Thanks, Mom. Hopefully I will recognize if I am going in circles and realize that I may have cut too many corners. More importantly, hopefully I will plan accordingly to begin with.

Recently I have witnessed a business that believes they are taking the time to plan accordingly. However, each year this organization goes through thorough planning that takes all the leadership of the organization weeks to develop and also takes them away from their business units for the all up planning sessions. They plan big changes each year in the organization with Manager Accountability Plans, and personnel changes. They leave the meetings with excitement in the belief they will drastically alter results with an increase in performance. Each business unit goes back to their respective organization and starts the beginning parts of the execution plan, which are usually the personnel changes. Personnel changes are disruptive and effect the momentum. The business units work through this process to get back to a respectable performance, however, this organization then alters their Manager Accountability Plans and stops implementing the changes. What were once great ideas or an exciting vision is wasted by the lack of execution. Employees become confused and frustrated. They start going around in circles.

Unfortunately, this organization has executed like this for several years. Leaders that have been around through this entire process become exhausted and human nature asks of them, 'Why should we do this planning if we never implement?' Personnel changes take an effect on people's lives and those that are still around witness the lack of execution and because performance is not improved they question if the changes were worth it. They become cynical in their points of view as the organization has been losing trust among employees. Their employment has become a job and not a career. Then the organization announces more sweeping changes and more great ideas. They fail to realize that their people are going around in circles because the organization has cut too many corners.

D) GOD ALLOWS US TO SLEEP SO WE CAN DREAM

My father was always an early riser as I believe it may have been from his military background. We as children would be awake early on the

weekends doing our chores and when done we would go back to our rooms and sleep. I still have the habit of waking up early on the weekends as it is instilled in me. I remember when the woman we knew as grandma would visit from Texas. My father's real mother died when he was two years of age so the lady that lovingly raised him was grandma to us and a mother to my father. She had so much love and loved all of us. So, as I mentioned, when she would visit from Texas we would be up very early as we would help in preparing the items she would utilize in her cooking. We would grate longhorn cheese, as back then there were not bags of pre-shredded cheese you could buy at the store like today. We would cut onions as well as other ingredients for whatever she was making. I miss those times and would gladly wake up early to have one more moment.

Mom would be up early too, but she always took an afternoon nap. She enjoyed her naps and we always made it a point to be respectful and not make loud noises so that she could nap in peace. Mom would tell me stories about her dreams as many of her dreams seemed to be centered on her brothers and sisters growing up. She would tell me funny stories about my uncles racing a horse buggy and a truck across one of the fields on the farm. She said they went over bumps and everything in the buggy was shook around. At the end of the race they realized that their father, my grandfather, had been taking a nap in the back of the buggy and their race had woken him up angry, I suppose. She would tell me many stories of her Mom and Dad as I never knew them because they passed away when she was young. I believe she would tell me the stories so I would know and appreciate my heritage and the lessons that she learned from them. This story still makes me laugh today.

Anyway my mother would always encourage me to get enough sleep. She would at times suggest I go take a nap if she believed that I was tired. I always believed that this was her loving way. But I do remember that Mom would ask, "How was your nap?" and she would ask about my dreams. When I would reply that I had no dreams or that I did not remember them she would press a little more. Funny, but the next time I took a nap and she would ask I started to remember my

dreams. Perhaps she believed that by quizzing me on my dreams, it opened my mind to being more aware of them. Sometimes I question if my mother was some sort of genius or if it was just her loving ways that brought meaning.

I remember one time as a teenager after taking a nap I walked to the kitchen where Mom was. I grabbed some orange juice and sat at the kitchen table where Mom was reading the comics from the newspaper. Mom asked, "How was your nap?"

"Okay, I guess," was my response.

"Did you have any good dreams?" she asked.

"I don't remember. Well, I kind of remember. I dreamed I was working at a different place and I was much older. I seemed to enjoy where I was working at," I stated.

Mom quizzed me some more and it seemed that each time I would remember more. I believe her quizzing made me more self-conscious to somehow remember my dreams better. Mom seemed to always be open to talk about my dreams and she took pleasure if the dreams seemed positive in nature. It was about this time that I asked her, "Mom, why are you so intrigued by my dreams?"

Mom's response was a lesson, like she had it waiting in her back pocket, waiting for me to ask this question. "Mijo, because I believe God allows us to sleep so we can dream and then wakes us so we can live them. This is why I ask you about your dreams because I believe many of them are telling you what you can accomplish or what you want to accomplish. Mijo, in your dreams there is no one telling you that you cannot accomplish what you are dreaming. That only happens when you live life. So mijo I want you to remember your dreams and how it feels in your dreams when there are no barriers. Because God allows you to sleep so you can dream and then wakes you up to live them."

Mom's response was amazing, as I thought she was just having friendly conversations all of that time. But with Mom there was always a lesson. A lesson that would last all of my life. I remember as a young adult I wanted to change careers. I was successful in what I was currently

doing and had even just won an award for being Manager of the Year, so the idea of changing seemed ridiculous, or not smart. But it was Mom who I sought advice from. I explained my vision that came from my dreams. Mom knew, as she taught me that dreams become part of your soul and spirit. She had those past conversations to teach me to allow myself to dream, but more importantly to remember them and remember how uninhibited I felt in accomplishing things in my dreams. Mom knew by remembering dreams they would become part of my spirit, as mentioned.

So there I was discussing the feeling and belief that I needed to change careers. Mom listened intently and asked a few questions. But then she asked the single most important question, "Mijo, what do your dreams tell you?"

"They tell me I will be successful in what I want to do," I answered.

"Does your heart tell you the same thing?" she asked.

"Absolutely," I answered.

"Then what is stopping you?" she queried.

I hesitated. Then I answered, "I guess because others are saying it is a bad move."

Mom did not hesitate. "Mijo, you will always have distractors telling you that you cannot accomplish something or that you should not do something. You need to listen to your dreams, spirit and heart. It is important that you have those that advise you, but be careful of the naysayers, because you will find more people who squash dreams because it is easy to do. Don't let them stop you from living your dreams."

I listened and I made the change. Mom's lesson of dreams has played over so many times in my life. The change in careers I made back then had success. My dreams gave me the courage to write my first book, become a speaker, and to teach others. As leaders, it is important to identify the dreams of those we are leading. It is not taboo as a leader to know those you are leadings personal goals as well as their professional goals. When we can understand that personal and professional goals can affect each other, we can help our people live their dreams. If their

dream is building a bigger house or going to Hawaii, then I want them to live their dream. I have to show how their professional goals tie into their personal goals and then we celebrate them achieving both. But helping individuals achieve their dreams creates an environment of loyalty and a culture that everyone wants to be a part of. As leaders we need to teach that God allows us to sleep so we can dream, then wakes us so we can live them.

E) GOOD THINGS HAPPEN TO BUSY PEOPLE

Mom was always big on teaching us to be of good character. This was encouraged through many conversations and lessons while I was growing up. She was a firm believer that good character will allow an individual to make it through trials and challenges. She would always state that failure or setbacks would occur, but not allowing anyone to question your good character was important. She would warn against taking shortcuts or crossing the line of ethics because to her there was no distinction between crossing the line a little and crossing the line a lot. She also believed that when you sacrifice your ethics and integrity once it then becomes easier to do again the next time.

Mom was also big on teaching us to always put forth effort and show that we work an honest day, which meant we did not cheat our employer by slacking off or doing other things besides work. She believed stealing time from an employer was the most common way people would steal. She would explain that if we are getting paid for each hour we work, we need to show we worked each hour. She said employers would recognize our work ethic and that would become part of our character. As we would become leaders those that we are leading would see the example we set and follow.

I remember having a conversation while discussing the lack of effort that other team members were exhibiting during a poor sales month because the team had already believed they could not obtain their goal, so in a sense they gave up. I was not in management yet with this

organization, but my goal and the team goals were important to me. I knew that our manager had goals as well and it bothered me that others were less concerned or gave less effort. Sometimes I believe that some of the other representatives would utilize excuses whether some had validity or not. It just seemed that they found reasons why their lack of activity was valid. I remember this discussion with my mother.

"Mijo, what is bothering you?" mom asked, as she could tell my quietness was a sign of being frustrated.

"I am just frustrated that it seems some of my fellow workers are not giving all their effort to drive our results," I stated.

"Is there a reason they would not drive the efforts?" she questioned.

"I think they see we can't hit our number. I believe some are holding back so they can have a better month next month," I replied.

"What about you mijo are you doing the same?" she asked.

"I try not to, but it's hard when you see them playing around you and not working. Is it wrong for them to hold back for next month?" I asked.

"Mijo, is it wrong for them to steal from your employer?" Mom countered.

I hesitated with a response as I did not understand the question. At first I did not correlate it to the subject at hand, but I gave an answer I believed was obvious. "If employees are stealing then of course it is wrong."

"Mijo that is what they are doing if they are not giving the effort your employer hired them to give. Even in a bad sales month they are still paid to give effort and make every sale possible, are they not?" she asked.

"Yes, Mom I understand. They are still getting paid for what they were hired for, but not giving the effort in which they were hired for?" I inquired.

Mom answered, "Correct son. But also understand that even if you believe that sales are not there to be sold then remember that good things happen to busy people. I truly believe this. The people who still give effort and work an honest day, good things will happen to them.

Sales will occur unexpectedly, the next contact will be a great customer for life, or many other things can occur. In addition, by working an honest day and giving effort you will line yourself up to be more effective the next day and the next month."

Mom was so correct. I would find that if I kept myself busy as expected and which I was paid for, that good things would happen. Sometimes great things would happen and sometimes small things, but they would happen to me because I kept myself busy and not to those who stopped giving effort. Good things do happen to busy people

Years later, and all through my time in leading sales teams, I would teach and mentor this lesson that good things happen to busy people. Many times I would have to coach it over and over and give examples. I would point to sport examples, like the former Spurs player David Robinson who was well respected for his good character. I remember reading a story once where a reporter commented that David Robinson was still pushing and giving strong efforts in the fourth quarter of a game where there was no chance of winning. David Robinson replied, "Last I checked they pay me the same in the fourth quarter as they do in the first quarter." What a great comment.

Remember that leaders are coaches, and coaches coach and repeat themselves constantly knowing that their message must stay consistent and players need to hear that message constantly. This is why we as leaders need to preach this message from day one of an employee's employment. We need to live it by example ourselves each day as a leader, and reward openly those that also set the example. We then need to point out when someone gives the effort and something good happens. It is important to teach and mentor our employees and leaders the culture that good things happen to busy people. This will instill a culture of those that will hold each other accountable. In addition, when you have someone that starts to slack in their efforts they are quickly identified by your leaders as well as the entire team. Winners want other winners on their team, and this is a great culture to have and maintain. But it starts with the lesson.

F) CONFRONTATION IS A BENEFIT

I have had many instances through my early adult life at work and in my personal life where I might have been hesitant to take action on an issue, or questioned if it would just pass on its own. For most of these instances the issue did not pass or go away but would either resurface at another time, or as it was in many occurrences, grow worse and affect others. Had I reacted when the situation first arose I could have corrected the circumstance, provided coaching and, most of the times, contained it from growing worse. It was after one of these occurrences that I gained insight on what effective leadership confrontation is from my Mother and why it is so important.

I was visiting for the weekend, enjoying home cooked meals and watching movie rentals with my parents. They really enjoyed renting the latest movies and the family would watch them together. Dad liked action and drama movies and was big on gangster movies of any kind. I joke when I tell people our movies we would watch around the holidays as a family were the Godfather movies. I would then remind whomever I was telling the story to that in the movie, the Godfather, Don Corleone was shot during Christmas time. It seemed like we enjoyed watching those movies over and over around the holidays and I will still sit down and start watching the movie if it happens to appear on television reruns.

However, back to the story of my current visit. The next morning I woke up and enjoyed Mom's breakfast. Bacon, eggs and homemade tortillas, sprinkled with a lot of love. It was during breakfast that Mom would ask about how I was doing and how was work. It seemed I always answered with a simple answer until I spilt the beans that there was more on my mind. I know Mom knew to just keep me talking and it would come out. This is when I described a situation that I hesitated to take action believing, or maybe hoping, that it would just pass and it didn't, it actually became worse and I regretted my hesitation. Mom asked a few more questions inquiring on why I hesitated and then she coached me. "Mijo, confrontation is a benefit. You need to learn to confront issues

quickly so you can address them, contain them, and work through them with correction."

It sounded so simple I thought smugly, "Mom, it is not that simple. I can't start an argument every time something like this occurs," I told her.

"Mijo that is not what I said. Confrontation does not mean to start an argument or to be confrontational in that manner. Confrontation means to take action and confront it, not allowing it to fester or grow. As a leader you need to address it professionally, based upon facts, and without emotion. This will help you maintain the fact that you are more concerned about the issue than who is right or wrong. If you allow emotion then you will have an argument. The important thing is to not allow things to not be addressed which can cause additional harm if you allow it to fester. Trust me mijo, confront the issues and you will maintain the culture you want. A culture that others respect." Mom then paused and looked for my response.

I sat there and as normal, I internalized what she said. That is one of my habits that I internalize what is being said to me before responding. But I realized she was so correct. We talked some more and she encouraged me to start confronting things from that point forward. But she also advised me to announce this to my managers that I evaluated that this was a weakness or a fault of mine and that for everyone's benefit I was going to start confronting issues. But in announcing this I also stated that confrontation was to be respectful and factual and that we owe this to each other and to our company. This seemed to work well, and educating everyone and showing humility gained buy-in and respect. The team was better for it. We incorporated leaders confronting issues and we became more effective in doing so as time went on.

As I developed over the years I have seen the managers who avoid conflict. These are the type of managers who believe, and even hope, that when a situation arises in their business and workplace that time will allow that issue to slowly go away. Unfortunately that is seldom the case. I learned this firsthand.

Strong leaders learn to address these issues right away, no matter how uncomfortable the issue. A strong leader realizes that if they address and confront the issue at hand, they can work to resolve the issue, learn more about the issue and its cause, and then get past the issue. This is what makes an environment of strong leadership.

Leadership training teaches that confrontation is a benefit. Confrontation is a benefit means to confront things head on, constructively, and professionally. This is what strong leaders do. They live by the philosophy and instill it in their team to confront issues with each other, with partners, clients, and yes, even their customers. One of my mentors taught me as an exercise to take all customer complaints. We had taken a struggling and underperforming business with the intent of turning around the business. This business had quality and service issues with their product as well as customer service issues from their sales people. It was a vicious cycle.

Confrontation is a benefit. This is what my mentor spoke to me using his own terminology, but it was confrontation. He stated that he wanted me to take all customer complaints. My mentor and manager witnessed that the sales staff would avoid taking customer complaints and even have the complaints redirected to email or voicemail. This resulted in a customer who became even more frustrated as their complaint was not being addressed. So we let the entire staff know that all customer complaints were to be forwarded to me. The receptionist and my administrative assistant knew we put priority on handling any customer complaint in real time. My mentor and I even drafted a four stage process to handle the complaints.

Soon I was speaking with clients as the complaints came in. We even identified situations quickly that might turn into a complaint and addressed those issues immediately. We became proactive. Not every situation was pleasant, but our customers were appreciative. They were glad someone cared enough to listen and then take action. As time passed we committed to correcting any of the situations that created the complaint. Because we confronted the issues, we learned more about

our business and saw things from the customers' point of view. We were able to put processes and practices in place that made us better.

By confronting the issues we earned long term clients and developed trust in our community. By confronting the issues we developed a culture within our employees of doing the same. The team direction and vision was clear and resolving issues became important to all.

You may have heard the term "First Team." It is not just a term or a dream, as it can be a reality that instills a culture that we address things and not let others address it with anyone else unless they addressed it first with the responsible individual.

Strong leaders do not let situations distract their teams. They confront situations to help develop and strengthen their teams. Whether it's an employee dispute, a customer service issues, or an issue with management, only by confronting the issue will we build a culture that automatically knows that leadership is leading. We cannot drive the culture we desire without confronting issues. Confrontation is a benefit. Teach it to your managers and watch them become leaders.

G) LEARN TO BE STILL

Recently I was doing a radio interview and the radio host had asked if there was one thing that I learned later in life that I wish I could go back and be better at. The host waited for my answer, which I responded to automatically, but I seemed to catch the interviewer off guard with my response. I answered, "I wish I had learned to be still sooner in life and understood what that really meant and how it was truly a benefit."

The interviewer seemed somewhat surprised as they may have been expecting a physical skill or something instead of a mental one. I then explained that this was something my mother would say to me growing up. She would say, "Mijo, you need to learn to be still. You are racing through life and racing through issues and you are missing out on opportunities and lessons. In addition, you are not aware of blessings and surroundings that are right in front of you. Being still at times will allow you to gain a better perspective and make better decisions."

I will state that I was probably in my teens the first time she told that to me. Unfortunately I did not absorb it at that time and allow it to change me, or understand the lesson. I raced in everything I did, believing that this was the proper way. This was my way of attacking life. Soon I found myself a father at the young age of eighteen. I took responsibility and raced forward. Having my first child so young brought challenges as I was still not fully mature myself. But I had not learned to be still. Having a child so young and my other choices did make me who I am today, and I do not ever regret having any of my kids. Each are a treasure and a blessing. But even as a young adult with children I needed to learn to be still. Remember, being still would allow me to enjoy and be aware of my blessings and surroundings, and after you race through life you cannot get that time back. I wish I learned to be still earlier in life.

Funny, but years later there was a song that spoke about learning to be still. However, Mom spoke those words early in life to me and often, as a coach will repeat important messages. Sometimes a leader understands they need to plant many seeds and someone else might bring the water that sprouts an individual to learn the lesson. In addition, I know Mom often referred to the biblical verse that said, 'Be still and know that I am God.' She wanted me to trust in that message. Mom wanted me to understand that sometimes being still would teach me more than racing ahead and losing focus. When you understand your surroundings you then can understand your direction.

As years went by I learned so much more from Mom's message of learning to be still. I would have the benefit of strong mentors being still, allowing me to absorb the message and learn the lesson. By being still I was able to observe as other leaders would lead by example and each example had great value. Then as I would lead and mentor others being still allowed me to watch their growth, discern where they struggled, and be there when they stumbled. Being still even helped me prevent their stumbles and mine as well. I recently have had the pleasure of mentoring a young female employee these past few years and her hunger to learn

was matched with her ability to execute. She started as an admin, but as she was observed it became evident that she had the intelligence and skills to grow. She took to coaching and she showed me that she had learned to be still. She would follow the message and learn the lesson. She steadily showed advancement and growth.

This person took over a new role where she led a new team and executed well. She would consistently seek more guidance and more coaching. I now enjoyed that I learned to be still because watching her and mentoring her has made me a better coach and leader. She soon won employee of the year within a company of over 300 employees. Not to settle for less, she sought a new role which was more challenging and involved selling with a high accountability. We built a strategic plan, built the accountability around that plan, and set it in motion. The plan took a little while to develop, but we believed in the contents of the plan. Because the plan was built on the proper foundation, any adjustments were easily identified when evaluating the built in stages. Sales grew and this person has just earned the Million Dollar Award. For this, and being a part of her success, I am grateful that I learned to be still.

Leaders learn to be still and then teach others its importance. Those that grasp it sooner can grow rapidly and advance. Some leaders that may need to learn to be still may be obsessed with the next big idea, but because they cannot be still no big idea gets fully executed. However, because they have not learned to be still they may not even know why they constantly change things. Making proper business plans and implementing is a lesson in learning to be still. If the business plans are built on the proper foundations as well as the execution plan being followed, then successful results will ensue. If constantly changed, you will never know if the plan ever had validity. Organizations need to evolve or they will eventually die. But the misconception of constant change is not evolution, but destruction. Evolution comes from being still and understanding the surroundings, the needs and goal. Then evolution can truly bring revolution.

In business we are looking for success, but as we teach others when, and how, and why they need to learn to be still. Then they will also find the satisfaction in achieving that success. Observing my friend Crystal and watching her growth has been extremely satisfying and it validates that as I focus on others success mine comes naturally. That is the epitome of leadership. Mom wanted me to understand that. I believe Mom knew she had a luxury back then by being able to be a housewife, but also saw it as an added responsibility to maximize her lessons to each of us. In today's society, and with mothers that work, I am in awe on how they still are awesome mothers and leaders that teach and mentor their children. Most of all I believe moms understand the lesson best of learning to be still. They certainly find the joy and the rewards in their children. Thanks ladies.

H) STOP, LOOK AND LISTEN

It is funny perhaps, that I write about this lesson right after the 'learn to be still lesson.' But stop, look and listen is a separate lesson with added value and for additional moments. Learn to be still allows and teaches leaders that being still builds the ability to discern, focus and enjoy much more. This lesson is a lesson my mom taught me to drive the point of my awareness in a moment of time to grasp all the information that is around me to make the best determinations and decisions.

Like many of Mom's lessons there was not just one moment in time that she utilized a phrase or statement to teach me. There were several times and several instances that she would feel the need to pull out one of her phrases. More importantly, however, was the education she would bring with the phrase. Mom believed it was important not to just make a statement, but to explain the statement and then in her explanation define how it relates to the current situation. This was leadership coaching at its best. Mom knew if the message was important enough for me to learn and if that lesson could adjust and build my character in a positive way, then she would use the lesson and she would repeat herself constantly.

There I was as a teen first, as it seems Mom had so many new lessons and statements when I was a teen that were different than when I was younger. Mom knew that as a teen I was elevating to a new stage of development, and therefore there were new lessons. Another great trait of a leader is understanding that development has stages and knowing the stage of who you are teaching is important. I had recently missed about a week of school or more, which in school days and the lessons of the classes, is a lot of material. One of my favorite classes was always math as it seemed to come easy to me. However, with my absence I missed some big stages of our lesson plan in my math class and catching up was going to be a challenge. In addition, because I did find math easy I sometimes may have had the attitude that I could race right through it and master it. Racing through it can be a danger that lurks for all of us in a topic that we may believe we are gifted in.

So I had extra assignments and extra time assigned to me in school for the missed math lessons. However, I just wanted to dig in and get it done rather than to listen to how my teacher outlined how he wanted me to work the subject matter and lesson plan. This kept causing a little friction and frustration as he would instruct me, but I would only listen half way and then do it my way. When I thought I was completing portions of the plan I would submit and receive the corrections for what I did not do as outlined because I did not listen completely. My complaint was that within the lessons my answers were actually correct, but that the outline on how I received the answers were not the way the teacher instructed me to work the problem. To my teacher, showing I followed the process to obtain the right answer was as important as having the final answer correct. I just wasn't listening.

Finally, this situation made it to my mother by a call from the teacher who cared enough for my learning to reach out. Mom approached me as I arrived home and I explained the situation to her as I certainly thought she would see it my way and defend me. I thought incorrectly. Mom stated, "Marcos, you need to stop, look, and listen when your teacher is explaining what and how he wants you to do something. You

need to stop, so he knows that you are paying attention. You need to look and show respect and awareness to anything he is showing you. Then you need to listen openly to everything he instructs you to do. You need to understand that you are the student and that he is the teacher. In addition, you have to trust that if he wants you to follow specific steps to show how you answer a question then there must be a reason."

I listened to Mom as I really had no response. I believed first, I could see that defending me was not an option, and secondly Mom just clearly made sense. When I returned to school, and before the teacher could address me, I mentioned to him that I had reworked the problems his way and turned in the assignments again. He thanked me for turning them in and nothing else had to be said. The next class topics and assignment dealt with problem solving and within the problem solving an exact method had to be utilized and demonstrated in solving the problem. So the prior lesson was designed by our teacher to teach us to break things down in stages for us to show how we broke the problems down. So learning and executing the prior lesson the proper way was extremely important to succeed in the class. Mr. Crane, my math teacher, knew that my learning this way was important enough to get involved. I am thankful that he did.

In my adult years my mom would utilize the lesson of 'stop, look, look and listen' many times over. However, depending upon the circumstance she may have explained each stage of that lesson differently based upon the objective desired. Another great understanding of a leader is to utilize the same lesson with the flexibility to define the lesson within the current objective. Mom did this well many times throughout my life.

Later in my adult years I was employed with an organization that was in the early stages of franchising. They were growing rapidly and I excelled in what I was doing. I was employed by the ownership of one of the early franchisees who invested in several locations. As the business developed and grew we needed support from the franchisor. In a new franchise organization there are many needs to help support the hiring and training of new employees in addition to adapting to the local and

changing markets. As a leader within a franchise ownership group, we would seek and make requests of what we believed would be beneficial for our business. Sometimes this created challenges and areas of void in what was needed. This was becoming a concern.

I remember a trip back home to visit my parents, as I now lived in another state, so visits became that much more special as they were not as often. A visit back home always brought the same warmth and feeling as we would break out the movies and the home cooking was always a treat. I treasured just sitting in the living room with family. I remember one of the days, while sitting around at the kitchen table, Mom asked about work and the challenges I faced. I was happy to tell her about the business, the fast pace, but also the challenges with a young franchise and the issues that this was creating. I explained that at times this caused me to lack materials to utilize to support my staff. It was at this time that my mother used the phrase again. "Mijo, you need to stop, look, and listen as I said before. Sounds like instead of struggling with the issues each day and just complaining about them you need to stop and make an assessment of what your current needs are and what your short term needs might be. You need to look around and see how the current status is affecting your people and what their ideas might be as well. Share your thoughts but allow them to share theirs as well. This way they will see you are making an effort and they will appreciate that. Then you need to listen not only to your employees, as I stated, but I am sure that if your ownership is having these issues then other new owners of the business are as well. They may have solutions already and also ideas."

Wow, Mom had great advice. I listened, maybe asked a question or two, and took her advice in. As I returned back to the work environment I did stop, look, and listen as my mother described. Our employees had great feedback and we implemented several items that were built on best practices that were flushed through properly. We spoke with other franchise owners to share ideas and came to realize that we shared the same challenges. From there we participated with the franchisor who was very receptive and they were smart to embrace many of the great

ideas and would roll them out network wide. It was at that time that I would be asked to present and teach at our network wide events and we would participate in the building of new materials and give feedback for updated manuals. The whole organization flourished and it was awesome to see the success of the network.

In more recent years I have had the pleasure of working with and coaching what is labelled as the millennial workforce. I will state here that I see this workforce as one that has the most courage demonstrated that I have seen in a long time. Perhaps maybe because they were born in the digital age that I had to learn as it developed. The millennial workforce, from my experience, you will find more that you have to slow down than to have to push forward. They are eager and hungry and want to learn. In addition, and one thing that I have learned about this workforce, is that they also want to be led. They, like others, have an innate desire to find leadership and if found they will be loyal. Others have stated that the millennial workforce will jump around from job to job, but I believe they are looking for a leader to show them a career. That is the difference.

However, in managing this workforce in a new department that was created, I have witnessed new coaching areas that arise, or maybe just expanded. I remember working with one millennial employee who is excelling because of her courage, but she also would race into every situation. She believed and has been accustomed to instant gratification or answers that society teaches today and it has taught her the habit of everything is to be at a fast pace. It was with this in mind that she was looking for an answer and advice on how to work with a client. However, every time that I would start to coach her at some point she would interrupt the conversation because she was in a rush to contact the client back. It was at this moment that I stopped her from interrupting and told her Mom's advice. "Suzie, you need to stop, look, and listen. Slow down for a moment. You are too much in a rush to get back with the client, but if you do not slow up you will be doing a disservice to your client because you will have an incomplete solution. I need you to stop

and be aware of the whole situation with the client and their ultimate objective. I need you to look around at other solutions that we have provided other clients so that you may have suggestions and ideas when you speak with me. Then you also must look at me for the guidance and listen. You need to listen to the coaching I am giving you so you can execute and you need to listen to the client for their responses when discussing your recommendations so that you can respond."

She took the coaching, which is what has helped her in her success. She went and executed with the client and because she implemented the 'stop, look, and listen' coaching, she has grown. She now has a sign hanging in her cubicle that says. 'Stop, Look, & Listen.'

As you see, 'stop, look, and listen' happens throughout life and in business. Mom knew this was probably one of the most reoccurring lessons to be encountered and taught. Great leaders know the important lessons and they know they are not taught once and remembered. Over time those we coach become better with stop, look, and listen, but the issues and objectives change when the need arises. This is why Mom always had the lesson ready and we as leaders must teach this to our future leaders of tomorrow.

CHAPTER 5

Maturing Years – The Older Adult Life

A) LIFE IS NOT ALWAYS CONVENIENT

There are many things that we learn the hard way. This is why life has lessons I believe, so we can learn, develop and grow. In my twenties I had my kids, whom my parents adored, Mom especially. She gave them her unconditional and unwavering love. Not having known my real grandparents I am glad that they were able to know theirs. I believe we all at some point build up a reliance that our parents will always be there or that there is a security that we take for granted. It was convenient to have them there as they were always willing to help and assist each of us. In some ways we probably took advantage of that.

I remember at certain moments something would happen or needs would arise unexpectedly. The car would need a new clutch or something in the house needed repairing. Speaking for myself, I believe I knew I had a safety blanket in knowing I could reach out to my parents for assistance. Mom and Dad would always assist and I know I must owe them even today for things they helped me with. It was at one point that my Mom made a statement for a lesson she knew I was ready for. She

probably knew I would not grasp it immediately, but she also knew that planting the seed of the lesson was important as I needed the awareness of what she was stating first.

At the time, and like many people out there, I was managing my funds paycheck to paycheck. I had stable and good employment, but was not too focused on what was ahead. So I always had money from my paycheck to pay bills as they were budgeted, but was not well prepared for surprises. When surprises would happen I had the benefit of Mom and Dad. I believe in this area Dad was the soft hearted one that was always there to assist. However, then came a moment when I was asking for assistance and my father agreed to assist that my mother pulled me aside and asked me a few questions. "Mijo, what happens next time when this happens, what are you doing to prepare for that?"

"Right now, Mom this just caught me off guard as I budget based upon what I am paid. All I can do is my best," I answered, and probably sounded defensive.

"Marcos," she stated. "Life is not always convenient as surprises will happen. Your father and I will not always be here and you need to make yourself aware of your situation as you have a responsibility to your family to be better prepared. Problems will not happen when you are ready for them. They will happen when you are not ready for them. Life is not always convenient," she repeated.

"I know Mom," I replied. "I'll get there. I...."

She interrupted, which she seldom did unless she was going to make a point she believed important. "Marcos Antonio, I see you spend money on other things. Things that are nice to have but not always necessary. You probably believe that those purchases at the time are okay because you have the money at the moment. But that is when you need to put that money aside, for when life is not convenient."

Mom called it like it was. She was honest, factual, and blunt because she knew she needed to be. Mom knew it was an important lesson for my adulthood, as life would have plenty more in store where it would show

me that it was not convenient. Mom also knew that for me to be a leader and provider of my family that I had to be better prepared and that this lesson would transcend into my leadership of others in a business. As the years went by, I had so many lessons of life demonstrating that it is not convenient. I actually find myself teaching this to my children, and my son-in law. I remember my son-in law worked hard on paying down all his debt and credit cards. A noble accomplishment. However, when he had completed that my daughters car, his wife, was damaged through no fault of their own, but it happened. He was frustrated as he had just found himself out of debt. Although I assisted financially I still took advantage of the moment on the lesson that life is not always convenient.

Obviously I am sure we all have stories of life not being convenient. Children getting hurt, damage in the house and just things wearing out at the wrong time. But what we can do is start preparing as much as possible for the unknown. If nothing happens then perhaps our preparation can be a situation where we can help others. Life is not always convenient is an important lesson.

I can think of several moments where I had taught and mentored my leadership team on the lesson that life is not always convenient. One such item is where I preach to always be hiring, which really means to always be recruiting. I have learned myself this lesson and how life is not always convenient when it comes to building teams within a business. I have seen so many times that the moment that you believe your team is built and that you need not hire any more, that one of your best employees resign. People get opportunities to better themselves and at times your best performers will leave you, or they may have other issues. I have had some of my best performers have medical issues or other issues in the family. Sometimes people just want to live their dreams and your business was a stepping stone. Teaching that life is not always convenient is an important aspect that helps business leaders do better business planning and execute important aspects like keeping their recruiting activities going.

In recent years I have seen in our business, as well as in a few other businesses who leverage their resources in certain areas, may run into the dangers of putting all of their eggs in one basket. Certainly any business would want to focus on their key strengths and not spread themselves thin in anything that they do. However, there is a balance and when not aware of the imbalance a sudden shift in the economy, states or federal laws, or resources can all of a sudden place the business in jeopardy. The recent economic downshift in the oil industry has effected many industries other than oil, as many other businesses relied on the success of that industry and provided services to support it. If it is known that a business or your business is heavily leveraged to one industry, then during business planning it is always smart to execute the lesson that life is not always convenient to understand the dangers, see if there are solutions and create plans to either lessen the leveraging or at least bring an awareness that you are leveraged and have execution plans if something causes a shift.

Life is not always convenient, as mentioned above, is actually a great leadership exercise to teach when mentoring, but also to utilize in strategic planning. The lesson flows in strategic planning where you list out dangers or scenarios of "life is not always convenient' with your business leaders. You teach the leaders to think of areas within their teams and then within the whole business. You may have to point to examples like their key personnel and ask about their back up plans if that person chose to leave the next day. You then can point to the products or service you provide and ask about scenarios if those products or services became limited, or is there a need or opportunity to expand in any of those areas? The best part of working this session is you are teaching your leaders to look out for potential pitfalls and be prepared ahead of time to possibly avoid them or to at least have a plan if something inconvenient occurs. This is the exact mindset Mom wanted to and succeeded in instilling in me. Today I may have a human emotion if something inconvenient happens, but I am at least much more prepared for it.

B) FEAR IS BETWEEN SUCCESS AND FAILURE

This book is about leadership lessons that I learned from my mother and how that formed who I am today. It is also about how it has helped me be a leader, teach others about leadership, and instill leadership in business today. Within those lessons from my mother were many lessons from my father, as well as both parents, that made an impact in my life. However, because my mother was a housewife there were many more lessons I directly learned from her. But Mom also wanted me to learn from my father, especially in areas of courage. I know Mom admired him for being a man of courage and for attacking life to support her and the family they created. He not only provided, but provided well. Dad not only furnished the necessary things to support his family, but he created an environment for creating memories. Mom then built upon those.

I know that I mentioned before that my father was a Drill Sargent before I born. Our upbringing was a disciplined one as it was my father's natural nature. In addition, my father was a man that all through my life I never saw him display any fear. In fact, the only time I heard him speak of fear was when he knew he was dying of pancreatic cancer and he mentioned it once. But as we took care of him and until the day of his death he demonstrated incredible strength and faced this fear head on. He has always been the biggest example of courage I have ever known.

In our old neighborhood, in my younger years, we always played hide and seek with all the neighborhood kids. One evening some of the kids were attempting to hide in a neighbors bushes and the owner of the house was not pleased. I could understand that people want privacy of their property, but this man was over the top. He started physically threatening the kids who were around 10 to 12 years old. My older brother was around 16 years old at the time so he tried to intervene, which escalated the situation. The man of that house started to move in towards my brother giving the impression that he was going to hurt him.

At this time, my father was at home meeting with a Real Estate Agent and signing papers as we were planning to move. A neighborhood

kid ran to our house and yelled through our house window, "Mr. Villareal, some man is threatening Chris down the street!" My father did not hesitate. He immediately came outside with the Real Estate Agent looking on from behind him. My father started walking down the street toward the gentlemen's house with all the neighborhood kids starting to walk behind him. It was like a scene to a movie.

As my father approached, the man stood still observing that my father was getting closer. My father took off his watch, placed it in his pocket and made the statement, "If you want to fight, its time you pick on someone your own size!" The night was incredibly silent. Eventually the other man backed down. That is a good thing, as no one really wanted it to escalate. You cannot imagine the pride I took as a 12 year old kid in the fact that this was my father. Growing up there are many other stories about my father that are similar to this one. My father never hesitated to protect us. Thankfully no harm ever came to him in any of those situations.

As the years passed, I was in business with my father. Through the years my dad was always larger than life to me, and he always provided. But what was amazing is my father's history. He lacked a higher education, yet was a partner in a business and provided well for his family. The business we were in together was actually part of his retirement plans. My father wanted to own a market and turned it into a success. When we would discuss my future, he wanted me to understand one key thing. He stated, "Fear is between success and failure." I asked him to explain. My father elaborated that fear was natural and that humans will fear. The difference being that with fear we would have to decide which direction we would go. Fear could drive us to failure if we allow it to make us freeze and not take action. Fear could also drive us to success if we decide to attack it, build plans to overcome it, and even learn to embrace it. This one lesson told me everything about my father. He was the epitome of facing his fears. Fear is between success and failure, my father chose to focus on the success.

It was after working within my parents business that I started my own restaurant. It was a sports themed restaurant with a satellite dish to receive different sport games. The recipes were mine for homemade burritos and the sandwich recipes were from my father. The sandwiches were called grinders. I remember when planning the restaurant and visiting with my mother that when I expressed uncertainty she repeated the quote from my father that fear is between success and failure. She then asked me, "Mijo, to face that fear and focus on success, what will you have to do to be successful?" It was a great question to get my mind thinking correctly. You see it may have been a lesson I learned originally from my father, but Mom knew this was the moment to remind me of it and utilize it for my benefit."

"That is a good question, Mom," I stated. "I was thinking about this…" and then I mentioned several things that I was considering. Mom would listen, ask more questions and knew that what she was really doing was working on teaching me on what I needed to focus on. This was her leadership way of not only telling me a statement but walking me through the lesson so I could learn. What she really did was recognize the fear and bring me to the confidence and desire that would focus on success, not failure. I owned that restaurant for five years, where three other competitors failed within that timeframe. It certainly took hard work but I was able to survive, have some success, learn from the experience and then sell the business. Mom helped me to remember Dad's lesson.

I remember after the restaurant that I was determining which direction I would take my life in employment. There was an industry that was rampantly growing, that was in technology, which was a subject matter I was less educated in. The business needed sales leaders who could build sales teams, which I was always good at, but once again I was unfamiliar with the technology business so in my mind I may have believed that it was not a choice for me. This became another topic of discussion with my mother. The decision to even pursue the position

was the first hurdle. Mom believed in my leadership skills and would ask me what my hesitation was. "It is a new industry Mom, so I am not sure that it is for me."

"Are they willing to teach you the technology mijo? I believe their interest in you is because of your leadership skills and experience in building sales teams," she stated.

"Yes, but it is a big learning curve, and plus it is a big move out of state," I replied.

Mom did not hesitate as she looked at me and repeated the lesson. "Mijo, fear is between success and failure. You may have failures in life, but if you address your fear by focusing on what it takes to be successful you will conquer and succeed. I know you will."

Mom gave me a lot to think about, and her confidence in me was motivating. I took the next step and started the interview process. I was hired and I moved to another state, which made the situation larger in my mind. But I faced the fear and worked to focus on what it took to be successful within that industry, learning curve and all. In a short time I became a leader in the franchise organization and worked in that industry for the next twenty years. Yes, fear is between success and failure. Thanks, Mom and Dad, for teaching me to focus that fear on the path of success.

C) WE GET THE TEST FIRST AND THEN THE LESSON

If you look at life with the wrong lens you may see only the potential challenges that lie ahead. Life certainly does have its challenges and many hurdles to overcome. But should the perception that life will be challenging alter how we live life? Should the fact that we know challenges will occur create caution within us, or even have us live a cautious life and take the safer route every time? Or should the reality of life have us plan better, prepare better, and keep calm when unexpected things occur? These questions can create two different views of how to live life and how to attack life.

I remember a time where I was having struggles on the job, and things would occur that were unexpected and new for me. When they would occur I would sometimes hesitate on how to react, and I am certain my hesitation allowed situations to brew and even grow. This was early into my management career and my boss would travel to the different locations on a rotation, so I did not have daily interaction that may have added value at that time. However, I certainly did have the opportunity to proactively reach out for help or counsel, but I hesitated and did not. When the problems grew my boss recognized the struggles and when we spoke he realized that I knew the problem existed for some time, but did not believe it was important enough to reach out to him. Which was the reason for his disappointment. We addressed the issue and developed plans in place to correct the situation. I remember the disappointment I had in myself.

I remember the next visit to my parents. Mom asked about work and I opened up about the situation. I explained that I had hesitated on bringing my boss into the situation because I thought it might make me look bad. By not making my boss aware, the situation became worse. Fortunately my boss coached me on why I should not have hesitated and the plans we put into place worked their way to success. But within the conversation with my Mom she stated something so true. She said, "Mijo, life gives you the test first, and then the lesson."

This sounded backwards and confusing. Aren't you supposed to get the lesson first so that you can study for the test? After all, that is how school teaches us. But Mom recognized my confusion in my hesitation and by the look on my face. So she spoke again.

"Mijo, life does not follow a lesson plan. It jumps out at you, and unfortunately life will give you the test first and then the lesson. Life will put you in a situation where you have to make a decision and react. Your decision and reaction is the test. Based upon that decision and reaction determines how well you did on the test. Once that is defined you will receive the lesson. The lesson is the consequence of your decision and

reaction. In this situation you hesitated and did not trust that you could or should bring it to your boss. His expression of disappointment, plus the problem escalating, is the lesson from how you did on the test. The final lesson was learning you could bring it to your boss. Understand?" she stated.

"I believe so, Mom. But then how can I be prepared for a surprise test? How can I be ready? It almost does not seem fair," I replied back.

"It doesn't have to be fair mijo, so beware. In addition, the way you prepare for a surprise test is the way you build your character. Why do you think I talk to you all the time about the importance of good character? If you build your life on the right values and principles and stand on those expectations that come from them, then you will be better prepared for a surprise test. Deep down your values and principles told you that you should tell your boss. But you hesitated. If you measure surprises against your values and principles then the answers are easy. Remember that I said the answers are easy, but the actions you need to take may be difficult," she explained with authority.

"Mom, what do you mean by the answers are easy, but the actions to take may be difficult?" I asked.

"Mijo, there will be times that you may need to fire someone you like, based upon the answers in a situation in which you are tested. So the answer presents itself, but taking that action may be difficult. But it is the correct answer," She said.

Mom made sense. She then pointed out things in my past that she had witnessed when I was tested that she believed I passed the test and received the lesson. But she also pointed out that even when I passed the test that the lesson still may be difficult. One example she gave me was having a child at the young age of 18-years old. When tested, I took responsibility. So in her eyes I passed the test, and she certainly loved my son. However, by having my son at 18-years old the lesson of taking that responsibility forced me to alter my life plans, and I certainly had my struggles as a young parent. But it made me who I am today.

I remember years later, while mentoring several up and coming managers and teaching them leadership, I had a manager who uncovered the fact that one of their employees, who was also a friend, was stealing. To me, the answer was simple, because I measured the circumstance against my values and principles. But as a young manager, he felt bad for the person and believed that maybe he should give them another opportunity. To some, the answer can sound so easy. But when life, and human emotions that we have sensitivity for, are involved it can become difficult. We like to look for the best in people and believe in humanity. The manager was in a test, and hesitated, and the person stole more. Now this became an even worse situation for the young manager, because when they were tested they failed, and something worse happened. Sometimes silence can make us complicit to the situation. It can damage the trust that we built and this is a hard lesson. The theft was discovered. The employee was terminated and the manager demoted. This was a hard lesson. However, that manager took the demotion with humility and worked hard to repair the damage caused by failing the test. The young demoted manager rebuilt the trust over time and worked his way back up successfully running a strong department. When tested, he immediately measured the circumstance against his values and principles and has taught others the same.

As I worked to expand my ability to mentor others, I have witnessed and encountered many examples of life gives you the test first and then the lesson. I then realized and took on the added responsibility to teach this to those we mentor. Mom taught me, and as shown there were times that I failed the test, and then hopefully the lesson although painful, was enough to mold me to be of better character. This is why we as leaders need to build organizations that demonstrate strong values and principles. We lead by example and must remember that even if we are not aware of it, that we are being watched. The manager that preaches values and principles, but then sacrifices them when being observed has lost trust, and this is detrimental to any organization. We cannot place

any higher value on teaching our leaders and preparing them for tests, as surprise tests will appear, and based upon how one responds and reacts, the lesson will follow. Thanks, Mom for helping me understand that life will give you the test first, and then the lesson.

D) SPEAK FROM THE HEART

Mom talked about character and she talked how a person should carry and present themselves. She would make this point in different ways, but the message and the lesson was important to her for us to learn. She believed that how you carried yourself defined how others would respond to you. Mom knew and taught that although first impressions were important that people would observe you over time and decide in their minds the person that you are. She was persistent to teach that if you have solid values and principles and as you demonstrate that you live them, that not much negative could be said about you. She was always cautious about me trying to get people to see me in a different light especially if it may not be really who I am.

Early in my management career I would witness other managers change their personality or put on a different persona to their team members. In my observations I would witness how their team interaction played out in the workplace. At times I would question if it was a matter of ego that changed their belief on how they conducted themselves, or if they believed that managers had to be different than a regular employee. In addition, my observations also witnessed a divide between a manager who conducted themselves this way and how their employees interacted. The strong sense of team did not show itself as a team unified for success.

I believe that I may have struggled to define that when becoming a manager, does your persona have to change? In addition, is this so that a manager can separate themselves from employees? Is this the mentality that we need in business? Is there a belief that managers must portray themselves as the boss so that they can demonstrate authority? From what I witnessed, the teams managed by those managers did not

show employees working with a purpose. Motivation of the team was adequate, but not high. Employees came to a job not a career.

On a visit with Mom, I explained the struggle and the concept that managers have to be different. Mom asked why I had that belief. I tried to explain that once you become a manager you need to separate yourself from the employees. It was also important for them to see your authority. Mom then injected her comment, "Mijo, just because you are a manager you should not have to change who you are. It is more important to be who you are, and speak from the heart."

"Speak from the heart? What do you mean, Mom?" I asked.

"Mijo, people will clearly see when an individual is genuine and when they are not. Don't let what you witness from other managers' fool you. You yourself just stated they changed their personality from who they were, or put on a persona. So obviously you clearly see it, and so do others. People will recognize and appreciate managers who stay who they are. They were promoted to be a manager because of their work skills and a belief that they have the people skills. To become a leader you need an environment where people will follow. No followers, no leading. A manager may believe that they are a leader because they have employees that report to them. But in the example that you just described, that manager is not leading their people and they are not following in the way of following a leader. They are just doing their daily jobs," she explained.

I listened and she made sense. That's why they had results. But they did not have a team environment focusing on the win. I then asked Mom for some more insight. "Why then, do you say speak from the heart, and why is that effective?"

Mom answered, "Mijo, everyone knows that you want to succeed as a leader and that you have goals and objectives too. They also know that you have personal goals that you may want to achieve for your family and so do they. So the only thing that makes you different is the title of your position and that you were chosen and have earned the position to hopefully lead them. So be yourself and they will recognize

that you did not change and appreciate you for that. Then, when you lead, speak from the heart always. When you have to address anything, good, bad, or changes, speak from the heart as people understand that business is fluid so things always have to be addressed. But you will see individuals who build a loyalty to your leadership."

Mom's lesson was so true. I worked on being genuine and to always speak from the heart. As I built and led teams I would gain loyalty. Really I would say I earned the loyalty of others. As loyalty is not something that you can demand. When you've earned loyalty you treasure those who are loyal, and speaking from the heart becomes so natural with them. Even when a hard decision in business has to be made. Because they truly know that you speak from the heart.

Having been in business so many years, and having the benefit and experience of leading different organizations as well as mentoring other future leaders, speaking from the heart is what I teach and coach. In one business we had to go through some layoffs, and that is never easy. We had to make some difficult decisions that would affect people's lives and when it became time to address, we spoke from the heart. We had earned loyalty and with that loyalty the individuals understood where we were coming from, and appreciated our honesty. Most remained friends and acquaintances, and many came back when business rebuilt.

One of the most difficult situations I had to lead and manage through, was when I was blessed with having so many single mothers working for me. I say blessed, because it was not my focus to hire single mothers, it developed naturally. I hired one single mother and she referred another. They were amazing as they had the 'I cannot fail' attitude that drove their success. We had other married or single employees as well, but I must have had about seven single mothers. They built my success and I earned their loyalty. I spoke from the heart and they appreciated it.

As time went by it was great to see how they were able to provide for their families and the personal pride they had in their achievement. We have employee picnics where we would play games that incorporated the families and this was awesome to experience. I remember one such

picnic we had a two player basketball tournament. One adult, one younger player. I had the 14 year old son of one of my single mothers as my teammate and we had a blast. I don't remember if we won the game but the memory of the family fun I have is a winning memory.

Two weeks later, tragedy struck. The young 14-year boy was rollerblading and was struck by a van. At first they believed he just suffered a broken leg and while his mother and her two children waited in the emergency room they discussed how they would have to prepare the house for a wheel chair. Then the doctor came and informed them that her son had passed away. Apparently he had internal bleeding that they could not control. Such a shocking and horribly sad moment. I can still feel the hurt and sorrow today.

When you build loyalty, you also build a family, and we all were shaken. When you build a business where we all know and love each other's families and we enjoy seeing them grow, we are all equally devastated. This affected us all. We were solemn and supportive and there for our teammate. However, the difficulty in the tragedy, we still had a business to manage and results and objectives to achieve. How do you as a leader manage to still run a business and help others to have at least enough focus to fulfill the needs that our jobs carried? You speak from the heart. You share in the pain, you show you understand the grief, and you provide counseling or counselors if needed. But you also speak from the heart about the business needs too. It is only because you have earned the loyalty of the others by speaking from the heart that they understand you at a moment like this. Hopefully, I always speak from the heart.

E) DO SOMETHING THAT MATTERS EACH DAY

We all get busy in life, and it passes so quickly. I look back and I am amazed at the passing of time, the memories that I have, and the friends that I miss. It is when thinking about memories that I reminisce and I am grateful for a lesson my Mom taught me, that helps each day

to create the future memories that you will someday look back upon. It was at a time that I was racing through life, like I did so much in the early days of my adult life. I already mentioned my mother would always tell me that I needed to learn to be still, but she also taught me an additional lesson that builds upon that. She taught me to do something that matters each day.

It was at the time that I was in the family business with my parents. Even thinking of that time I realize what a joy that situation was being with them each day. However, I would work and then race off to what I was going to do after work. I had children of my own which my Mom adored. She cherished all of her grandchildren. But she also recognized that although she would always welcome them in her home, that I would ask her to watch them frequently because I always had something to do. One day, when I was dropping them off, she asked to speak with me. I tried to tell her I did not have time and she gave me the message and indication it was important.

"Marcos Antonio, you need to slow down." My first and last name spoken by my mother grabbed my attention. "You know I will always take care of the boys, but where are you racing off to that you are not spending enough time with them?"

I really had no answer. Where I was going and what I was doing was insignificant. Even rationalizing, or attempting to rationalize that there would be opportunities to spend time with them in the future, would be futile. Mom knew her point was valid and that it pierced my heart and mind. I was a fool. Even today I still feel shame. I can never get back time I did not spend with my children and, yet miss and love them so much. The song by Cat Stevens 'Cats and the Cradle' seems like it was written for me, and I am confessing it here in my book. Humility I teach is a strength, not a weakness, and this reality and confession is my most vulnerable moment. I sat in silence in my Mom's presence.

"Marcos, when you race through life, it leaves you with no purpose and no memories. You have beautiful things right in front of you to cherish, but you are looking for the next thing. Mijo, you need to do

something that matters each day. Do something that matters with your loved ones and something that matters with others you can impact. When you do that, you will seldom look back with regret," she spoke, so passionately.

I sat with my head down. I was in shame, but in reality there is no shame in being corrected. What you do from there is what matters. I remember gathering myself and repacking up my boys and letting them know that we were going to go do something. Just the look in their eyes and faces are a memory I cherish. We packed up and went and did something for them. It was fun and rewarding and better than anything that I had planned. That day I did something that mattered.

In business, and years later, Mom would sometimes ask me when talking about my work, "Did you do something that mattered today?"

Sometimes I would have to think for an answer, and sometimes she would bring it out in questioning. She would probe, "Did you take time to mentor someone today? Did you encourage someone and did you work to help others grow?" she would ask.

Mom, I believe, always saw the leadership potential in me, or she knew she taught me from an early age. A mother's impact can be so significant. From her questioning, I would have answers, as from each of those examples I would have an example and would answer back so excited.

"Yes, I did, Mom," I replied back and must have sounded like a surprised or excited child. With my Mom I probably always was a child. "I am mentoring this person in this department. She started as an admin and is growing now so rapidly in another department." The conversation would go on to other examples. Mom knew that doing something that makes a difference each day would impact me and more importantly impact others. Her way of asking about it was an additional part of the lesson. First, it reminded and demonstrated to me that doing something that makes a difference each day is rewarding. Second, it demonstrates that it helps others and builds them for better things. Ultimately that is also what built the success that I had over time by making a difference for others.

To me, the definition of leadership is doing something that makes a difference each day. This is at least a tool as well as a responsibility of leadership. Leaders understand, believe and accept that they have a responsibility to do something that makes a difference each day. When you do that for future leaders they pay it forward. When you do that for your family you are rewarded with smiles, joy and love. Most of all you are rewarded with memories.

I remember at another time Mom used this example when she was concerned about my health. Once again I would hit a cycle where I was always on the run and she would recognize the scenario and intercede. Mom did not worry or care if she repeated herself or brought things up too many times. Mom worried or cared that her children learned, that we were safe, and that we were healthy. This was a mother's love with a leadership heart.

"Mijo, slow down, you look awful. Are you okay?" she asked in concern.

"Yes, Mom, just been busy on the job. I have a lot to do and work is going through a lot of changes," I answered, sounding out of breath.

"Marcos Antonio, no matter how busy work is you need to take care of your health. Do you need something to eat mijo?" she asked.

"Sure." I would never turn down Mom's cooking. I could have just come from eating pizza but Mom's cooking was the best.

Mom then reminded me of the lesson. "Mijo, you need to do something that matters for yourself each day. I know that you are always busy and doing things for others, which I love you for. But doing something that matters each day is something that you need to do for yourself as well. Your health is important. Your body and mind will get tired and all the good that you have done would be wasted on your health. You need to do something that matters each day for yourself mijo. Only then can you sustain doing something that matters each day for others. You need to have balance in both."

Mom was so right, as usual. I needed to do something that mattered each day for me as my health was suffering. So last weekend, I did nothing but relaxed. I did something that mattered because my body

and mind needed it. We as leaders must do something that matters for us, or how else do we refuel. Spending time in the Bible refuels me. Reading leadership books by other authors and swimming in my pool are additional examples of things that matter that assist me in unwinding. When I take care of myself, it replenishes my spirit and increases my desire to keep coaching. Doing something that matters hopefully will keep me available to continue to mentor others. Keeping my health in line will allow me to enjoy watching others grow and become successful.

F) CHEER ON OTHERS

The world need cheerleaders. Now that first sentence in a book about my mother teaching me leadership may sound funny, but it depends what first came to your mind. I am not referring to the cheerleaders at football games, as the world may need those as well. What I am referring to is people who encourage and cheer on others. Mom was a cheerleader for me, as mothers are for their children. Mom wanted me to recognize the importance of cheering on others and the impact that it could have. Mom wanted me to cheer on others and not worry about who was cheering me on.

I remember going to a College Football game where I really did not know either team well. There was a University in our community and one time I decided to go to the game. My friend thought that it was funny that I would cheer on the local team, but because they were the local team it made sense for me to cheer for them. My friend knew I had no knowledge of the players so he just thought that this was funny. We went to my parents' house afterwards as they lived close by. The subject of the game came up when they asked where we came from. My father asked how the game was and I said it was fun to watch. My friend then said with laughter, "You should have seen Mark. He was cheering like he was really a fan of the team!"

My mother responded, "What is wrong with that? The world needs cheerleaders. We all should cheer for someone."

My friend kind of shrugged his shoulders and just took the answer in. I was not surprised by the answer as Mom always believed we should motivate others. But after a little silence Mom spoke up.

"You don't know how much being cheered for makes an impact. Especially where some of those players probably had no family in the bleachers. I am sure it felt good to hear cheers. Isn't that why it is said that home field advantage has value, because of the crowd cheering for their team?"

"I guess so," my friend answered.

Mom would tell me at times, when discussing work and talking about someone I was mentoring, "I am glad you are cheering someone on. It makes a big difference to someone when they have someone cheering for them. Someone telling them when they did something good and showing that they, and their accomplishments, are recognized."

The more I would see this in action, the more I would be a cheerleader. A cheerleader for a person and a cheerleader for a team. I also realized that when you truly cheer on others and you do not worry about who is cheering for you, that those you are cheering for want to see you get recognition as well. They become your biggest fans and cheerleaders and it creates such a strong culture. Mom knew this by instinct.

I talk about how at age 23 I read the book, The One Minute Manager and it changed my life. One of the most important concepts about The One Minute Manager is that it teaches in order to help someone grow, the key is to catch them doing something right. That has power and works on the positive side of coaching. In my leadership coaching I speak about rewards or consequences. How as a manager I would want to work on the side of rewards, but that the consequence side is still there. This is why the world needs cheerleaders, because individuals need to have someone cheering for them.

I once had someone say in a letter of recommendation about me that I had the ability to discover hidden talent in individuals and almost will them to success. If that was true, I would probably waste a lot of energy with individuals who never would develop into leaders because I

would believe I could develop anyone into a leaders. In reality I would discover that someone was coachable, hungry and that they had the intellect, logic and common sense to grow. Then they had to show the hunger and the commitment. When they demonstrate these, and also the right foundational values of leadership, then they already have the hidden talent and just need to be made aware of it and allow it to grow. Amazingly I have witnessed and had the pleasure of several individuals who started in an admin role and probably would have been comfortable staying in that role. However, they had all of the above and with me being their cheerleader they developed and became amazing as they grew and developed.

The hardest part about cheering for others and watching them grow is seeing them move to the next level or next opportunity that does not include you. You enjoy cheering so much you become a fan, and they yours. But sometimes life happens and the next one you will need to cheer for is waiting in the wings. They always show up, and soon you will be cheering and developing the next awesome leader. Cheering others on is the most rewarding action and function of a leader. Mom knew that cheering people on also developed confidence within that person and increase their courage. During that football game the running back seemed to really get stronger with the cheers of the crowd. Teams just rise up when encouraged.

Teach, preach and mentor managers that to become a leader you must be a cheerleader of others. Teach that as you cheer others they will in turn cheer others. Most of all they will cheer for you. The circle of business is built upon the fact that goals and objectives are built so that those who report to you must succeed for you to succeed. When they respond and grow from your cheering, they achieve and succeed. Then by them becoming a fan of you they will cheer and understand that you have goals and objectives built from theirs, so they have a natural buy-in and are invested in your success. The team becomes one big cheerleader of each other and they carry the coach off the field when they celebrate the victory.

G) EVERYONE HAS DREAMS, BUT FEW LIVE THEM

Life is so fast paced. I know Mom enjoyed the luxury that she had by being a housewife and spending each day with each of us. She would tell me that there was nothing more that she wanted or enjoyed. Today it is not so easy for mothers, married or single, they all amaze me with their tenacity to succeed and the desire to provide for their children. One thing I enjoyed most was our holidays and vacations as this was a point when my father provided extra for the family and the memories are fond in my mind.

Mom, I believe, was easy to please but she enjoyed her children, grandchildren, and great grandchildren. She just had so much love to give. What she seemed to enjoy and cherish most was seeing us happy. When we made achievements, she was our biggest cheerleader. When we struggled she was there to encourage, coach and correct. Mom wanted us to live our dreams. Mom wanted us to attack life and succeed. When I was young, she encouraged me to dream big as I wrote about earlier. She was not only open to hearing and listening about our dreams but she would probe us to tell her what our dreams were. Amazing as this is leadership at its finest, to encourage people to dream and to help bring those dreams to fruition.

I remember in my young adulthood that I hit what I would call a roadblock in life. I had a dream to own my own business and build it to success. I just hit a mental state where I did not see that the vision of my dream was possible. I would look at magazines and write down ideas. Sometimes I just wanted to at least say that in my life I lived this dream, whether successful or not. Many of us have a bucket list of things that we would like to accomplish in life before we die. Owning my own business was such an item. I just did not foresee it as a reality.

Mom saw the discouragement in me. A strong leader recognizes changes in those they lead. Mom would sometimes probe, to see if I would work it through. She also knew when it was the moment to intervene and coach her son. "Mijo, what is bothering you?"

I shuffled the magazines that I was reviewing, and then kind of pushed them away from me in a show of discouragement. "I am just looking at pipe dreams Mom. Nothing that I would ever be able to accomplish."

This caught Mom's attention, as she never liked us speaking negative about ourselves. "Marcos Antonio, the moment you tell yourself you cannot accomplish something is the moment you convince yourself to give up."

"I know Mom, I appreciate the encouragement. But some things are just out of reach. Unless I hit the lottery or something," I responded.

Mom sat down so she could look me in the eye. "Mijo, everyone has dreams, but few live them. Few live them because they believe they cannot achieve them. Few live them because they convince themselves that they are too far out of reach. Even if their dreams are big, to believe you can obtain them is the first step in accomplishing them. Never giving up on that dream builds the desire in your heart to one day accomplish them. You will be amazed at what doors open if only you keep believing. I want you to believe that you can live your dreams. Some may happen quickly, and others may take a long time, but keep believing and doors will open."

Mom spoke with a passion, and her passion inspired me to keep that dream. A few years later I owned my own restaurant with my own recipes. It was a Sports Deli with a satellite dish and it was mine. Because I kept that dream in my heart, the desire never left and amazingly a door opened. I owned that restaurant for five years and sold it. Other restaurants that were my competitors failed during that time, but I made it through five years with enough success to have someone want to buy it. It was challenging and hard work. I worked long hours, especially when others took time off work. But the restaurant was mine and I can say that I lived a dream. I lived a dream that I almost convinced myself that it could never happen. Until Mom intervened.

Years later, I read a book that taught how to write out your dreams into five different categories. In business we teach what a BHAG is, which stands for Big Hairy Audacious Goals. The book, being a spiritual

book, spoke of Big Hairy Audacious Prayers. Because I believe God truly has a hand in my life my list is around 100 items, because I dream big. I have a category on how I can influence others, and magically I published my first book. I have dreams for my family and children, and I am dreaming for big things with each of them. Because I have a list I have big dreams and I believe that doors will open because of that. If I did not have a list of my dreams then how would I recognize or be aware when a door for that dream opened.

Several years ago, when leading a business and building upon our success we implemented a deeper goal setting process. We included, and asked for, personal goals and in my presentation I spoke of dreams and how important that personal dreams were to professional dreams. I spoke of many of my personal dreams and how my professional goals helped me achieve a personal dream. I quoted my Mom, in fact I wrote it on one of the whiteboards of the planning room. 'Everyone has dreams, but few live them.' I explained the story and how believing in dreams was important. I explained how as a team knowing others dreams and seeing them achieve their dreams only would inspire us more. I was amazed at the impact and how the meeting took on a life of its own as others would talk about their dreams and how some were achieved in amazing ways.

Everyone has dreams, but few live them. By having a list I am actually excited and motivated to push towards each one. The author of the book stated how amazed he was on how many items on his list that he accomplished. If we have no list, we may still have dreams, but maybe not as many. But if making a list helps you in believing that you can achieve more and challenges you, then make a list. This is what drove our business. We have individuals that have posters of their dreams hung at their desks. Whether it was Hawaii for a vacation or Harvard for their child. They had dreams and we all celebrated when they were lived.

Leaders understand motivation and when they uncover some magic in motivating others they want to use that magic on everyone.

My mother knew that when teaching me on this lesson. She encouraged me and then taught me to create new dreams. She encouraged me to accomplish more. This is exactly how we should lead. We should not only teach, coach and mentor others in believing in dreams, but we as leaders need to challenge our individuals that there are more dreams out there for them. I remember meeting with an individual as I was recruiting him for our business. I remember laying out a dream on how moving over to our organization would be good for his future. He saw the dream and believed in the vision. He now is part owner of that business. How did this happen? Because everyone has dreams, but few live them. Except the few I know.

H) PRIDE, PRIDEFUL AND PRINCIPLE

What mother does not have pride in their children? Mom certainly had pride in us. This is why, how we lived and carried ourselves mattered to her. Teaching us about values and principles was her foundation for us to develop properly and therefore learn to take pride in ourselves for the right reasons. Mom would teach the difference between being proud of accomplishments and being prideful which can be developed with an unhealthy ego. She believed that being prideful can make one blind to their surroundings and reality.

Early in my younger years I was discussing one of my courses which was in drama. I seemed to have a knack to do well in drama class with acting, speeches, and directing the school plays. It was about this time that I became a little arrogant and that arrogance created a sense of becoming prideful in me. I would judge others and be quick with an opinion on their shortcomings. I would compare how I would do their role or speech better with the assumption that mine would be better. I probably just assumed that I was God's gift to drama. It did not take long for Mom to recognize this and take action.

"Marcos Antonio!" There it was, my first and last name, she definitely had my attention. "You are sounding prideful and it is starting to bother me," she exclaimed.

"What?" Like I was surprised. "Not sure what you mean? I take pride in what I am doing. What is wrong with that?"

Mom sighed and turned her body in her chair to face me directly. "You are confusing pride and being prideful. Pride, when healthy, is okay. I want you to be proud of your accomplishments. But being prideful will blind you to your own weaknesses. In addition, it will blind you to where you can truly help others. Finally, it will ultimately stagnate your growth because you will not seek your own improvement. You will not humble yourself to learn from others as you will believe that you have all of the answers. At some point you will see others pass you by and you will not know why. It is the arrogance that comes from being prideful."

I sat silently and probably still fought in my mind what my mother just stated. By being prideful my arrogance did not want to believe it. But when my mother spoke with a passion she earned my attention. She always had good points. When a leader has coached you through so many situations, and what they coached you on has proven to be correct and of value, you tend to listen each time they speak up. Seldom does a true leader need to remind you of past situations of advice and scenarios unless it is part of the current lesson.

I looked up and asked softly, "How do I change that? How do I avoid embarrassment when I go about that change?"

Mom's answer was quick. "With humility." We then discussed it a little more and Mom gave me great advice on how to address the change head on. She further advised me to reach out to those I showed this arrogance to and ask how I can assist them. When I followed this advice there was some apprehension by those I reached out to. But as time went on the others in the class opened up and in addition I learned so much from them.

In my adult life I have had to circle back to this lesson and the next stage which I call pride versus principle. We all know that a principle is something that is built out of your values and a principle is something that should be automatic, or else it is not a principle. It was at a time that I was visiting for the holidays, as I then lived in a different state. Visits were

not as easy and when you live in a different state it becomes easier to get disconnected. I looked forward to the visit, seeing family, eating Mom's food and talking to Mom. I had a few things that I knew I wanted to discuss. During this timeframe, new ownership had just taken over the business that I was employed in and they were making major changes. These changes I believed would be detrimental to the business. I questioned them personally and I started to hear similar questioning by other managers. Sharing in that discussion I knew was not proper. However, sharing the concerns to the new management professionally would at least allow me the opportunity to voice the concerns, which is what I did. The conversation seemed to fall on deaf ears, so this frustrated me even more.

In my conversations with my mother, she was always great at listening to the story I had to tell and she also would gain an assessment of my temperament. I believe great coaches utilize this approach so they can understand how to respond to the current situation. Mom would ask questions if more insight was needed and sometimes her questioning would lead me down a path of self-discovery. Many times her questioning was a method to allow me to regain my senses so I would be level minded for her lesson.

"Mijo, why does it bother you that they made changes?" she asked.

"Because we implemented the things that they are now changing and they were working. So there was no need to change them," I replied.

"I understand, but when you brought up the concerns did they listen and give you time to explain?" she further asked.

"Yes, they did, but they still stayed with their changes, so it seems my concerns fell on deaf ears," I answered.

My mother rebutted my comment, "But you just told me that they listened to your concerns. Did they or did they not?"

I stuttered in my reply, "Yes they did, but…."

"Mijo, if you had concerns and they allowed you to voice them then that is all that you can do. It sounds like you are more frustrated that after listening to your concerns that they decided to stay with the changes," she stated.

I was quick to answer. "Yes, but they do not have to make the changes, they….."

"Marcos, they were cordial to allow you to express your concerns. But if they own the company then they can make the ultimate decisions to make changes. That is their prerogative. It sounds more like your pride is what is frustrated and also that you are confusing pride with principle," she interrupted.

I became a little defensive in my posture. "It's not pride, Mom. They are wrong to make changes."

Mom responded quickly with questions. "Are they wrong because the decisions are unethical, illegal or dishonest?"

"No, they are none of those," I responded. "But can't they be wrong if a decision is just bad?"

"Mijo, lets separate the two. If their decisions do not sacrifice a company value and any of your values, then they have the right to make that decision. If their decision turns out not as effective as what you are presently doing, then I am sure that happens all of the time in business. However, because they own the business, they have the right to make the decision and make the changes. If their decision sacrificed company values and your set of values, then you can stand on principle. I will always understand that kind of argument. But because you believe that their decision is not the right decision and they still choose to move forward, your pride is bruised and you are trying to use the excuse that it is the principle of the matter, but you have already stated that no values are sacrificed. Therefore you have no principle to stand on. Mijo, don't confuse pride and principle," she elaborated.

Mom was correct, my pride was bruised and I made myself believe that they were wrong and it was a matter of principle. But there was no principle to stand on. Over the years I have seen so many scenarios where pride and principle were confused by others and it would not allow for decisions to be made and it was the crux of many disagreements. In future years I would be an arbitrator on several encounters where the brightest minds would refuse to take a step back and question if

they were confusing pride and principle. It is from this experience that I defined the words so I could utilize them in future mentoring and in future encounters.

Pride: Having a feeling of being good and worthy. A common understanding of pride is that it results from self-directed satisfaction with meeting a personal goal.

Principle: A principle represents values that orient and rule the conduct of persons in a particular society. Ethical standards are considered to be principled.

Pride versus principle. The definitions could not look more different. Yet, I am amazed on how often these two words, when in action, get confused. Perhaps those taking the action are not confused, but they simply try to convince themselves that their action is based upon principle, when they are really basing it upon pride.

The many definitions of pride are confusing as well. Pride can be both good and bad. We may take pride in our work, our appearance and our family. But the pride that brings on stubbornness and can make us blind to the truth can be destructive.

It is human nature to naturally want the satisfaction of proving yourself, or proving your opinion to be correct. This is an internal battle we face as leaders and as managers. Great leaders learn to decipher the difference between pride and principle. More importantly, leaders learn how to teach others the difference and that by using humility as a leadership strength one can learn to take a step back, admit when its pride and not principle, make a correction, and move forward.

So there I was, mediating an argument between two successful business owners, when all the facts were on the table and we see that the dispute was over less than $100. Let me say, $100 is important, and certainly something to be concerned about. But the dispute arose more from unintended circumstance than from anything malicious. In addition, these business owners managed businesses that generated cash flow in the multi-million dollar range annually.

So back to the dispute: answers were sought and solutions were offered. The dispute could have been rectified in an easy and quick fashion, but one participant wanted to make a point. Because of "principle", as they claimed, they wanted to carry the dispute farther. This dispute took several weeks of conference calls and meetings. Three of us gave our time to every discussion, and time really is money, when not spent wisely.

The dispute went on, and because my time has value I had to ask and confront the one owner. Remember, confrontation is a benefit. I had to address the issue to the one owner and ask, "Are you sure you are not confusing pride with principle?" He seemed surprised. Of course it was the principle of the matter. But was it really?

There is a time and a place to stand on principle. When your organization is built on solid principles they should be automatic throughout. But when we confuse standing on principle to prove a point or to prove our opinion, we may be confusing this with pride. True leaders understand and mentor others on the difference.

I) GOD'S TIMING IS PERFECT (HER DEATH AND MY FATHER'S TRANSFORMATION)

From a young age my mother would always state that God's timing is perfect. No matter at what age, I believe that we all have expectations of instant gratification. We want things now and waiting is difficult. Do good things really come to those who wait? I am not sure. But I do know that many times throughout my life that I would witness that God's timing is perfect.

There was this promotion that I had focused on and worked hard towards within the organization that I was employed with. I believed that I had positioned myself well, vocalized my desires and did everything in my power to obtain it. When the position became available and interviews were conducted, I was prepared and interviewed well. However, when the decision was made they had hired someone

from outside the company. It was disappointing. The person was well qualified and they had the background that made not hiring them a hard decision. However, I was still disappointed and heartbroken. I believed this was my chance and I did not know if I would get another one. This opportunity looked so perfect for me.

Mom saw my disappointment and engaged me. "Mijo, I know you did not get the promotion, but you cannot let it get you down. There will be other promotions."

Answering back quickly, "I am not so sure of that, Mom. Plus this one was perfect for me. I might as well move on. I am sure there are other companies that could utilize me."

"Marcos Antonio, behave. Your employer has always been fair with you and you tell me that you like it there. They had good candidates, including you, and made their choice. More opportunities will come along," she assured me.

I believe I said something sarcastic in response. It was just a frustrating moment. Mom knew I was frustrated and she knew to give me a little space. But when I cooled down a little she brought me her lesson.

"Mijo, God's timing is perfect. You must believe that. When it is your time to be promoted, God will open that door for you. In fact, you may not see that now, but sometimes God will hold something back because it may be harmful for you or it may not have the promise that you thought that it did," Mom explained.

I grumbled, "No, this one was perfect."

Mom responded quickly, "Marcos, listen to me. Never doubt God. His timing is perfect, and sometimes this may be a test. Keep working hard and live your values and you will see God open a door. His timing is perfect."

Amazingly, God did open a door. Another opportunity came out of nowhere, or it appeared out of nowhere to me. When the opportunity arose it was at a time that it made a big impact in my personal life. God's timing was amazing. The funny thing as well is, the other promotion that I was not offered ended up within a department that was downsized

and the other person being released. Sometimes we do not realize how God protects us if we let Him. I did realize at that moment that God's timing is perfect.

From that day forward I have witnessed so many times that God's timing is perfect. By having that faith I am constantly learning to believe that God's timing is always how it should be. The moment that had a strong impact of understanding that God's timing is perfect was when my mother passed away. In my mother's last few years she suffered several strokes that made her wheel chair bound. My father, who was always the epitome of a strong, non-emotional man had to wait on her constantly, and he did it so lovingly. So, I witnessed how God transformed my father into an outwardly-loving man taking care of his wife with honor and grace. He showed each day with his attentive care how much he loved my mother. I also believed he realized that they were in their last few years. I witnessed that although it was hard to see my mother's health deteriorate, that God utilized her ailing health to transform my father. His timing was perfect.

Mom passed away from what was a doctor's error in her medication dosage. My father was given incorrect instructions, that by him following, her blood thinned so much that within a week she passed away. My father was devastated. He lost the love of his life as he would explain it. He wanted to be with her, in life and in death. But God was not ready for him. God was only ready for my mother.

We discussed, as a family, about legal options on the error made by the doctor's office. My father described how the doctor cried when explaining the error and my father mentioned on how much the doctor loved our mother. Although I would give anything for one more day with my mother, it was God's timing, and God's timing was perfect. Our family chose not to pursue any legal actions against the doctor's office as it was an error and Mom was frail. In addition, Mom was buried on her birthday, May 3, 2005. This was God's validation that His timing is perfect. I remember being in such amazing peace at her passing and I knew that she was in heaven. Her lessons that God's timing is perfect

prepared me for that moment. I miss her dearly and can still hear her voice. "Marcos Antonio", "mijo", or "my baby." I love you, Mom.

My father lived two more years, but his transformation was an additional testimony that God's timing is perfect. He moved to the small Texas town where my mother was born and buried so that he could look after her grave and take care of other unattended graves. The most amazing thing was how my father sought the Lord. My father was transformed from a stern, disciplined man to a man of the Lord who served the church and would witness to others. I know Mom smiled down from heaven. After a battle with prostate cancer and surgery, my father was diagnosed with pancreatic cancer and he demonstrated his toughness up until he passed. When he passed, the priest of the local church said that he believed there would not be enough room to hold everyone that would come to his funeral service. It seemed that the priest knew how many lives my father touched in serving the Lord in the short two years he lived in that town. When the service was delivered the church was packed and I remember strangers telling stories on how they came to the Lord because they witnessed our father serving. God is amazing, and His timing is perfect.

God once again demonstrated that although my father wanted to be with my mother in death that God was not ready for that to happen yet as God took the time to transform my father, make an impact on others and prepare him for heaven. I remember once again, although sad my father had passed away, that I had joy with knowing God prepared him for heaven to be with my Mom. I remember that my father had a riding mower that we purchased for him and complete strangers would come up after the funeral and state, "Your father used to come by and mow my yard."

I would answer back jokingly that he did not know how to turn it off so he would ride it until he ran out of gas. We laughed and we cried. But God's timing was perfect. Dad, give Mom a hug and kiss for me. I love you both so much.